CAMBERWELL

THROUGH TIME

John D. Beasley

AMBERLEY PUBLISHING

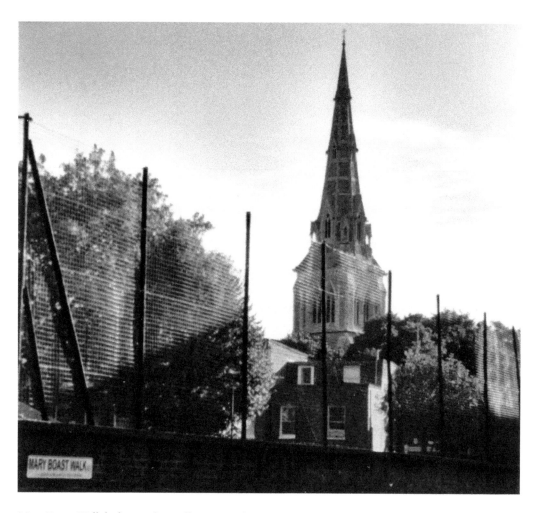

Mary Boast Walk links Camberwell Grove and Grove Lane. It is appropriate that the spire of St Giles's Church is in the background as Mary wrote a book on the church's history.

First published 2010

Amberley Publishing
Cirencester Road, Chalford,
Stroud, Gloucestershire, GL6 8PE

www.amberley-books.com

Copyright © John D. Beasley, 2010

The right of John D. Beasley to be identified as the
Author of this work has been asserted in accordance
with the Copyrights, Designs and Patents Act 1988.

ISBN 978 1 84868 563 5

British Library Cataloguing in Publication Data.
A catalogue record for this book is available from
the British Library.

Typeset in 9.5pt on 12pt Celeste.
Typesetting by Amberley Publishing.
Printed in the UK.

Introduction

An extract from the Domesday Book referring to Camberwell can be seen in *Ye Parish of Camerwell*, published in 1875. This invaluable book of over 500 pages, written by William Harnett Blanch, contains a huge amount of information about Camberwell's fascinating history.

The Story of Camberwell by Mary Boast is the only recent history book covering the whole of SE5 that is in the London Borough of Southwark. Part of SE5, including King's College Hospital, is in Lambeth.

This book is dedicated to Mary Boast who was Southwark's first Local Studies Librarian. Mary died aged eighty-eight on 21 June 2010 in King's College Hospital, a short distance from her home in Ruskin Park House, Champion Hill. Her funeral took place on 5 July 2010 at St John the Evangelist Church, Goose Green, where she was an active member. She wrote a book on the history of that church as well as St Giles's in Camberwell.

Just as W. H. Blanch left an invaluable legacy in his important book on Camberwell, so Mary Boast has left a vital legacy in all the books she wrote on the whole of the London Borough of Southwark. As a consequence of a conversation I had with Mary Boast in 1972, I wrote *The Story of Peckham*. Since then I have written about twenty other books on Southwark, London's most historic borough.

Though I have lived in Peckham since 1972, until then I had been a Camberwell resident for over three years in the attic flat at 192 Camberwell Grove, close to where Joseph Chamberlain was born.

When I changed jobs in 1970 I needed some temporary work, so for five weeks I was a Royal Arsenal Co-operative Society milkman based in their depot off Camberwell Grove. Every day (apart from two days off in five weeks) I got up at 4.15 a.m. and drove a milk float to Bermondsey. I never imagined in those days I would write a book on Camberwell – or any other subject!

Camberwell is a vibrant community with a huge amount of activity. Among the important organisations and events are the Camberwell Society, Camberwell Community Council, Camberwell College of Arts, SE5 Forum for Camberwell, Cambridge House and Camberwell Arts Festival as well as Tenants' and Residents' Associations and a large number of voluntary and statutory organisations and churches.

In recent years Camberwell has been neglected by Southwark Council, much to the frustration of Camberwell Community Council. Though the coalition government is making massive cuts in public spending, it is hoped that money will be found to assist Camberwell and its residents.

Many people who live in Camberwell care about their community and work actively to make Camberwell a good place for its residents and visitors.

It has been an interesting experience for me to write my first book on Camberwell, though I had written about it in the *South London Press, Southwark Remembered, Southwark Revisited* and *The Bitter Cry Heard and Heeded: The Story of the South London Mission of the Methodist Church 1889-1989*.

As Camberwell Old Cemetery is in SE22 and not SE5, I wrote about it in *East Dulwich Through Time* (page 78) and *East Dulwich: An Illustrated Alphabetical Guide*.

In *Who Was Who in Peckham* I wrote about the Camberwell Beauty. This butterfly was first recorded in England, in 1748, when two specimens were captured near the village of Camberwell, in what today is Coldharbour Lane. A picture of the Camberwell Beauty mosaic on the side of the former Camberwell Borough Council public baths and library in Wells Way can be seen in *Peckham and Nunhead Through Time* (page 22).

In 1994 the Cuming Museum had an exhibition entitled 'Concrete and Clay – explore Southwark's changing environment.' *Peckham Society News* stated: 'The new centrepiece of the exhibition will be a Camberwell Beauty butterfly, recently discovered in the museum's stores. It was thought that the Cuming Museum did not hold an example of this famous local butterfly, but two were identified during conservation work on its collections. The Camberwell Beauty is now the symbol of Southwark's Burgess Park, and will be shown alongside the changing face of the park.'

As a local historian I have been able to see parts of Camberwell that few people who live in SE5 have visited. In this book there are photographs I took from the roof of Southwark Town Hall. I have also seen the blocked up entrances to tunnels under Peckham Road that used to connect the two parts of Camberwell House, a lunatic asylum. Below is a photograph of a former cell that still exists. Uncontrollable inmates were locked in it.

Among the notable people who have lived in Camberwell are Robert Browning, Joseph Chamberlain, Lorraine Chase, Una Marson, John Ruskin and Muriel Spark. Countless other people who never achieved fame have played a part in helping to make Camberwell a pleasant place for its residents and visitors.

Camberwell used to be a Surrey hamlet. It grew into a village that became part of London when the London County Council began its work in 1889. From 1900 it was the main part of the Metropolitan Borough of Camberwell until 1965 when the London Borough of Southwark was formed. Camberwell has an absorbing history and will doubtless have an interesting future.

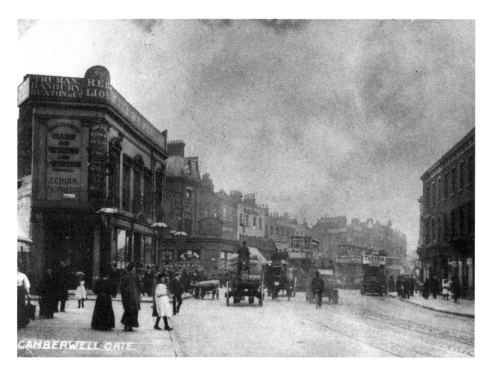

Camberwell Gate

A small part of the road between Camberwell and Walworth was known as Camberwell Gate. It was the site of an old turnpike gate that was shown on Horwood's 1819 map. In *The Story of Camberwell* Mary Boast wrote: 'A Turnpike Trust had taken over the old highway from the Elephant and Castle to Camberwell Green in 1782 and was allowed to collect tolls for the upkeep of the road.' The Red Lion still exists.

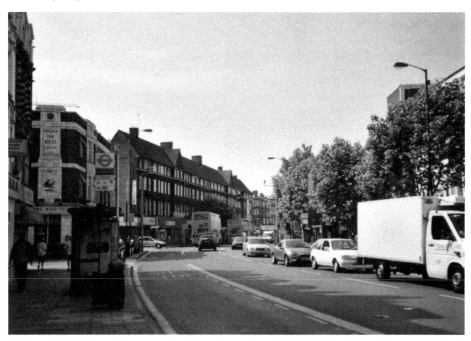

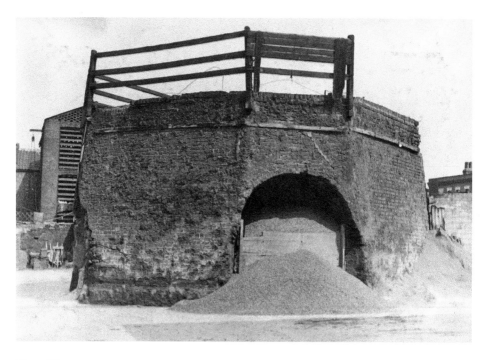

Lime-Kiln

The remains of Burtt's lime-kiln can be seen in Burgess Park. Burtt's Limeworks opened in 1816 soon after the Grand Surrey Canal was built. The kiln was used to heat limestone and convert it into quicklime needed for cement. That was in great demand as the area became increasingly built up with houses and other buildings. The kiln is one of the few reminders of how this part of Camberwell looked before Burgess Park was created. E. R. Burtt & Sons and the lime-kiln are featured in *The Story of Burgess Park* by Tim Charlesworth.

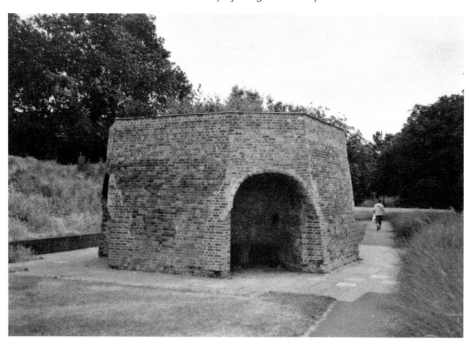

Grand Surrey Canal

The Grand Surrey Canal, seen here in *c.* 1925, opened from Rotherhithe to Camberwell in 1811. The story is told in *Retracing Canals to Croydon and Camberwell*. Though the canal closed in 1971 there are reminders of it in Burgess Park, including a nineteenth-century bridge and a long path where the canal used to be stretching almost from Camberwell Road to Trafalgar Avenue. History of the canal is included in *The Story of Burgess Park* by Tim Charlesworth who wrote about children who were drowned in it.

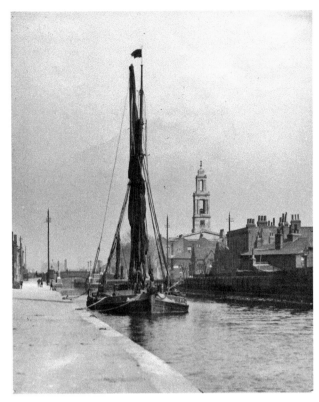

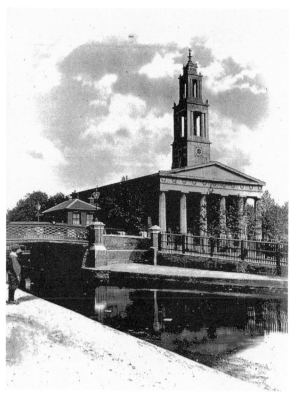

St George's Church
St George's Church in Wells
Way was consecrated in 1824.
A drawing of the church in *Ye
Parish of Camerwell* by W. H.
Blanch (published in 1875) shows a
windmill close to it. The hymn tune
'Camberwell' written by Michael
Brierley was dedicated to Geoffrey
Beaumont who was then the vicar of
St George's. He helped with the final
version of the tune.

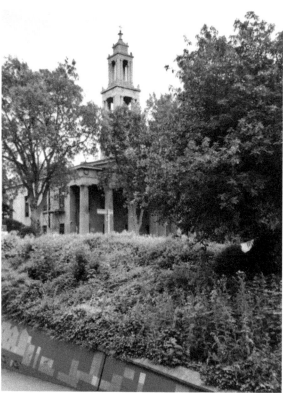

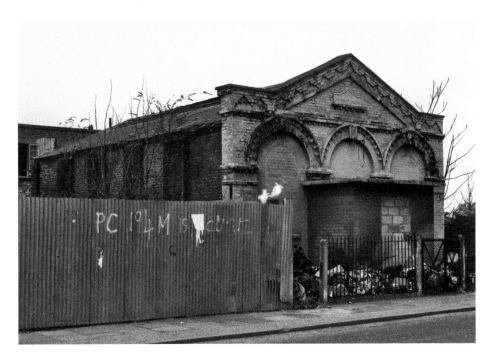

Zion Methodist Church

Zion Methodist Church in Neate Street was opened in 1855. There was a plaque outside stating that William Booth preached there. This was when he was a Methodist New Connexion Minister. He later founded the Salvation Army. The chapel is one of many buildings that existed on land where Burgess Park was created. A potted history of Zion Chapel is included in *The Bitter Cry Heard and Heeded: The Story of the South London Mission of the Methodist Church 1889-1989.*

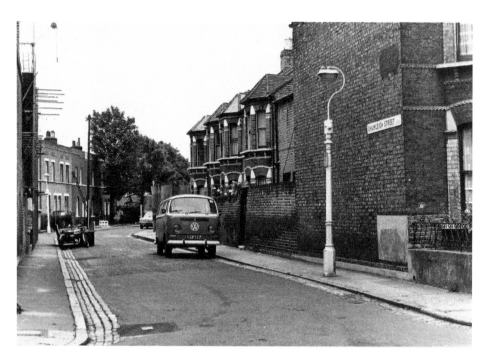

Chumleigh Street

Chumleigh Street, built in 1869, was photographed from Albany Road before it was demolished to make way for Burgess Park. A book on the history of the park was written by Tim Charlesworth called *The Story of Burgess Park: From an intriguing past to a bright future*. Burgess Park was named after Councillor Jessie Burgess who was Camberwell's first woman Mayor (1945-47). She was first elected as a Councillor for the Metropolitan Borough of Camberwell in 1934. For forty-four years she served on various committees of Camberwell Council and then Southwark Council. She died in 1981.

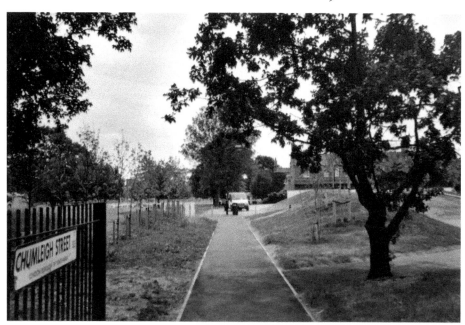

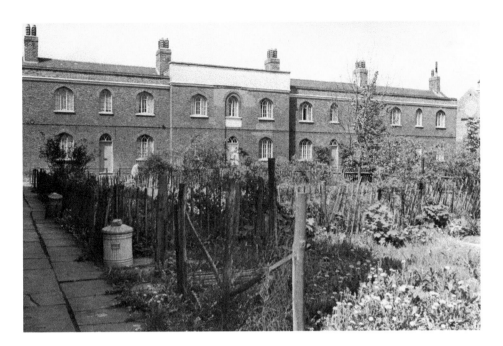

Chumleigh Gardens

Chumleigh Gardens were originally almshouses opened in 1821 by the Friendly Female Society. This was founded in 1802 'for the relief of poor infirm and aged widows and single women of good character who have seen better days'. At first the rules limited recipients of assistance to those living within five miles of St Paul's Cathedral. This was extended to seven miles in 1891 and later to ten. The Society was notable for the fact that even from its beginnings it was run by an exclusively female committee, although the trustees appointed for its property in 1821 had to be men.

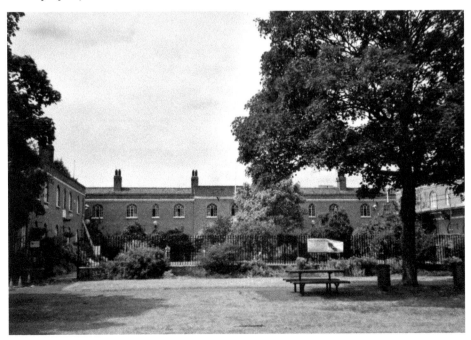

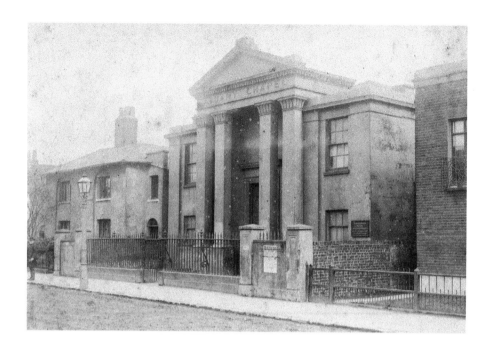

Albany Chapel

Albany Chapel is shown on Dewhirst's 1842 map of the Parish of St Giles's Camberwell. The above photograph was taken shortly before it was demolished in 1887. It was situated in Albany Road between Chumleigh Street and Cunard Street. Part of Burgess Park now covers the site. The chapel was originally built by the followers of William Huntington, a coal-heaver, but it was afterwards purchased by a few friends of the Revd George Rogers who began a ministry there in 1829. Albany Chapel is included in *Ye Parish of Camerwell* by William Harnett Blanch.

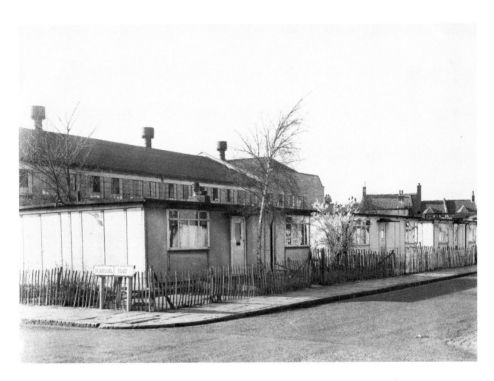

Jardin Road

Prefabs were erected in Jardin Street close to its junction with Scarsdale Road and on the site of houses that were bombed in the Second World War. The land is now occupied by part of Burgess Park. Scarsdale Road was built in 1861 and was named after Robert Leke, 3rd Earl of Scarsdale. He was groom to Prince George of Denmark, associated with Denmark Hill. The above photograph was taken in 1965.

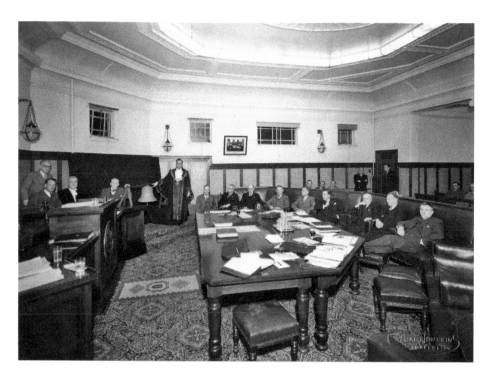

Scarsdale Road School

In 1950, the Mayor of Camberwell, Lord Ammon, presented a two-hundredweight school bell to Councillor W. R. Warner of Camberwell in Victoria, Australia. The bell was taken from the blitzed Scarsdale Road School; part of Burgess Park now occupies the site. The gift was in recognition of the 40,000 food parcels sent to Camberwell in London during the Second World War from Camberwell in Australia. The photograph shows the bell in Australia with the local Mayor of Camberwell.

New Peckham Mosque

The New Peckham Mosque in Cobourg
Road, also known as Noorul Islam Turkish
Mosque, is the former St Mark's Church
consecrated in 1880 but not finished until
1932 through difficulty in raising funds.
The architect of the chancel, part of the
nave and the south chancel aisle was
Norman Shaw. He also designed New
Scotland Yard, the former headquarters
of the Metropolitan Police on the Victoria
Embankment in Westminster. The Mosque
was founded in 1984 by Shaikh Nazim
Haqqani Naqshaband of Turkish Cypriot
origin. The photograph above was taken in
1977.

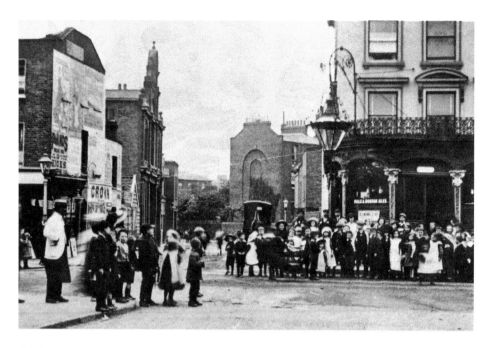

Addington Square

Addington Square, now a Conservation Area, was completed before 1855. The photograph was taken from New Church Road, *c.* 1900. Numbers 8 and 48 date from around 1810. On the north side, now an entrance to Burgess Park, early residents had a swimming bath. This is shown in Dewhirst's 1842 map of Camberwell. In *Victorian Suburb: A study of the growth of Camberwell* H. J. Dyos recorded that Camberwell Vestry created Addington Square Garden in 1897. The Revd Thomas Binney, described by W. H. Blanch as 'the large-hearted and noble-minded Dissenting minister', lived for some time in Addington Square.

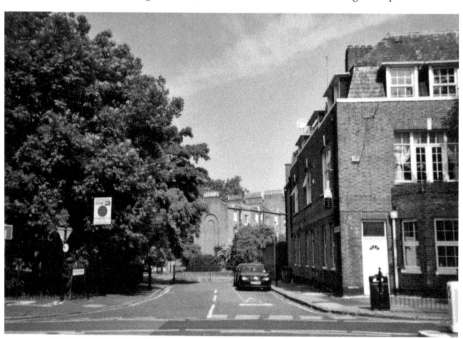

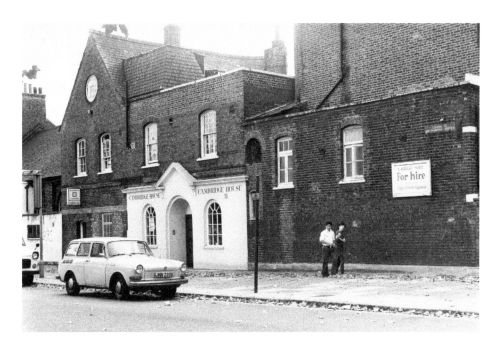

Cambridge House

Squires in the Slums: Settlements and Missions in late Victorian London by Nigel Scotland states: 'Trinity College, Cambridge established their mission in 1885 in the parish of St George's Camberwell with the Revd Norman Campbell becoming at the end of that year both vicar of the parish and Warden of the Mission. In 1887 a house for Cambridge residents was taken in Camberwell Road and renamed "Trinity Court". But a decade later in 1897 Trinity generously allowed the house and that part of their mission to become "Cambridge House".' Over a century later, it continues to do important work.

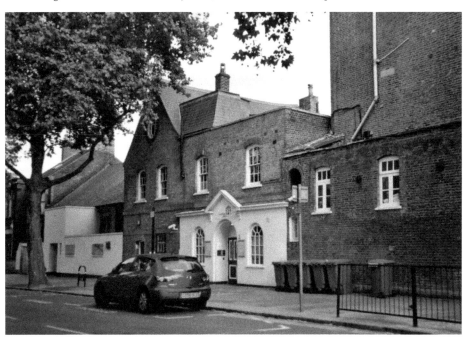

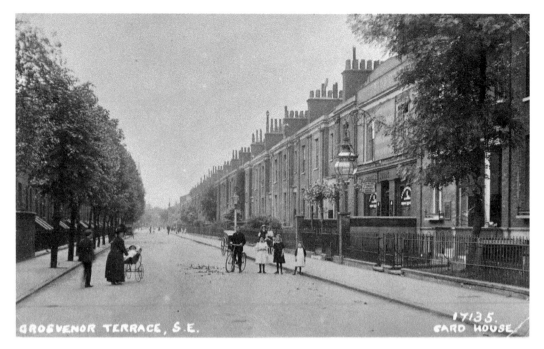

GROSVENOR TERRACE, S.E.

17135.
CARD HOUSE

Grosvenor Terrace

Grosvenor Terrace, previously called Brunswick Terrace, is included in *The Streets of London: The Booth Notebooks – South East* edited by Jess Steele (Deptford Forum Publishing, 1997). It includes much information from the seventeen-volume survey *Life and Labour of the People in London* published by Charles Booth between 1889 and 1903. When Grosvenor Terrace was surveyed in 1899 it had two and three storey houses. The survey stated: 'North side better than south.' Grosvenor Terrace includes an old entrance to John Ruskin Primary School.

Grosvenor Park

Grosvenor Park had a traditional red telephone box. This was designed by Sir Giles Gilbert Scott who was the architect of William Booth College at Denmark Hill. When George Duckworth and Sergeant Feador Sziemanowicz surveyed Grosvenor Park in 1899 for Charles Booth's famous study of London, they reported: 'Tallymen, clerks, very few servants, none on the south side. The east end opposite the church and the south side of the park are the best. Good gardens, majority have no servants ... Many lodgers, card with "apartments" or "a bedroom for a gentleman" in many windows'. The 1916 Ordnance Survey map shows buildings where the Grosvenor Community Garden is today.

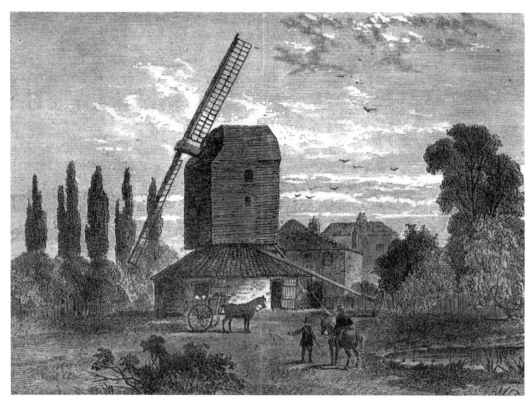

Camberwell Mill

Camberwell Mill, also known as Freeman's Mill, was close to where Horsman Street is today; its previous name was Windmill Street. In *Ye Parish of Camerwell* (1875) W. H. Blanch wrote that it had been 'a conspicuous parochial boundary point, being the first in this parish on the western side of Camberwell adjoining Newington'. It is included in *The Windmills of Surrey and Inner London* by K. G. Farries and M. T. Mason. The mill was demolished in the middle of the nineteenth century.

Sultan Terrace

Sultan Terrace, on the left, was photographed in 1939 with Gurney Terrace on the right. All Souls' Church in Grosvenor Park can be seen. The church was consecrated in 1871 by the Bishop of London. One priest who conducted the service was W. D. Maclagan, the Rector of St Mary, Newington. He became Archbishop of York in 1891. All Souls' Church was demolished in 1974. Flats were built after Sultan Terrace was demolished.

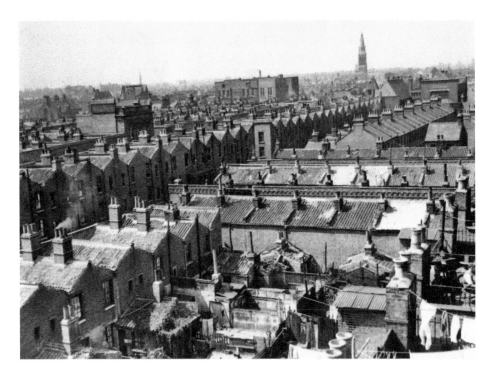

Sultan Street

Sultan Street, with the spire of St John's Church, Vassall Road, in the distance, was photographed in 1939. In Charles Booth's famous survey *Life and Labour of the People in London* there is a section on the Sultan Street area which is described as 'some of the vilest slums in London'. Sultan Street was called the 'citadel of poverty'. The Sultan Street area was called 'a collection of streets where beastly men and women live bestially'. Flats replaced the Victorian houses.

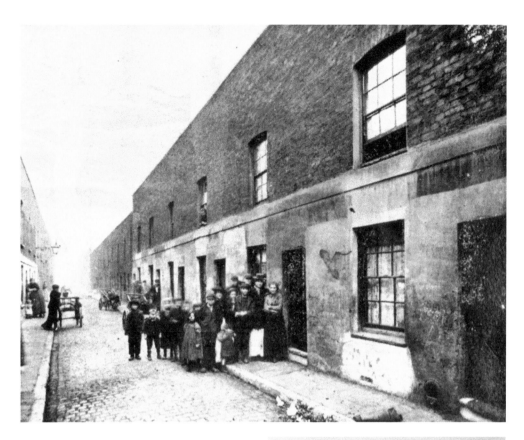

Bowyer Street

Bowyer Street is a reminder of the wealthy Bowyer family. A drawing of Bowyer House, in Camberwell Road, was included in *Ye Parish of Camerwell* written by W. H. Blanch. The book can be seen in the highly acclaimed Southwark Local History Library at the rear of John Harvard Library in Borough High Street. Bowyer House was demolished in 1861 after being purchased by the London, Chatham and Dover Railway so the line from the Elephant & Castle to Herne Hill via Camberwell Station could be opened in October 1862.

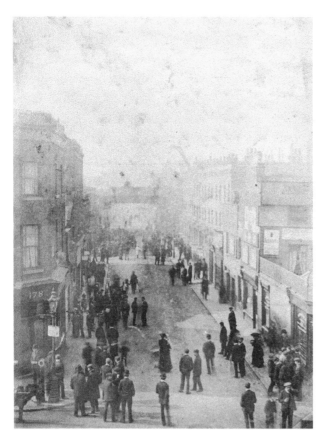

Wyndham Road

A brawl in Wyndham Road was photographed in *c*. 1910. In the same road today is Gwen Morris House. This commemorates Gwendoline Morris who was born at 45 Melbourne Grove, East Dulwich, in 1911. She attended Dulwich Grove Congregational Church and became a missionary in China and India. Her experiences are recorded in her autobiography *Go East Young Woman*.

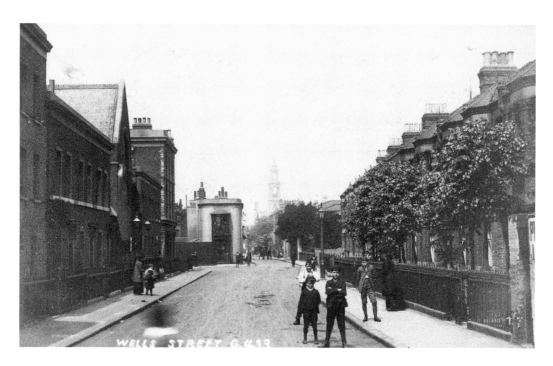

Cottage Green Chapel

This early twentieth-century view of Wells Way shows the school-rooms of Cottage Green Chapel; the latter opened in 1844. It became a Baptist chapel in 1854. Some time after 1859 the school-rooms were erected. In *Ye Parish of Camerwell* W. H. Blanch wrote: 'a Sunday school of about 500 scholars is successfully conducted by thirty voluntary teachers'. He also stated: 'a large and interesting Band of Hope meets weekly in the school-room'. The Well Community Church now occupies the site.

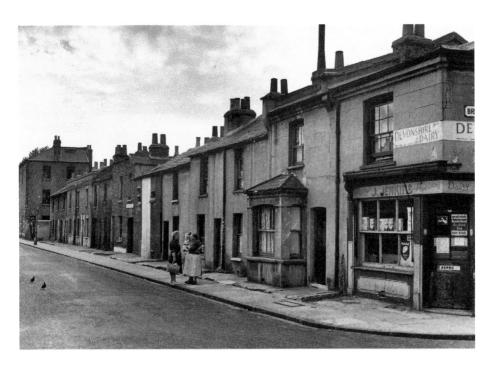

Picton Street

Picton Street used to cross Brisbane Street. This 1953 photograph shows the Devonshire Dairy at the north west corner of Brisbane Street. The shop and houses were demolished to make way for the London County Council's Elmington Estate. The LCC replaced Victorian streets with tower blocks that included about 700 dwellings. In *Camberwell Place and Street Names and their Origin* Leslie Sherwood stated that Picton Street was named after Stephen Picton, a seventeenth-century builder who repaired St Giles's Church. Brisbane Street commemorates Sir Thomas M. Brisbane (1773-1860) who was a soldier and astronomer.

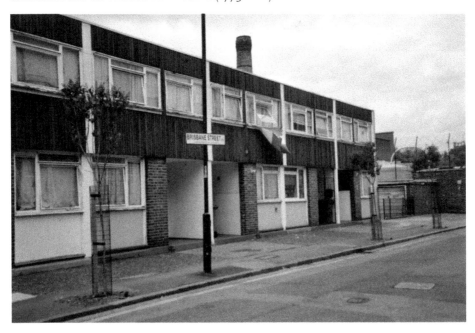

Emmanuel Church

Emmanuel Church, in Camberwell Road, stood where Bishopsmead is today. The first stone was laid on 29 June 1840 by Sir Edward Bowyer Smijth. He gave the land on which the church was built and also an adjoining house and garden for the minister. Later he provided the organ. There were galleries on three sides of the church, supported by cast-iron columns. The church could seat over 1,000 people; 511 seats were free. Pew rent had to be paid on the others. The church, seen here in 1953, was demolished in around 1965.

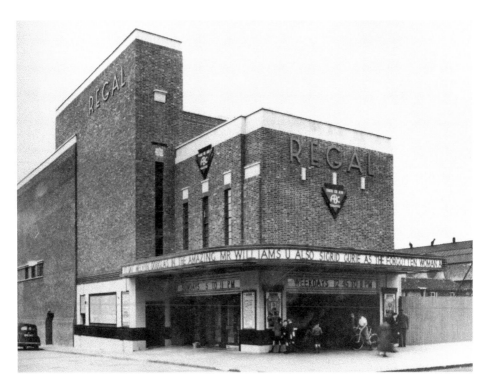

Regal Cinema

The Regal cinema in Camberwell Road opened on 17 June 1940. It was the last 1930s-style cinema that started to be built in London before the Second World War. It had a red brick exterior with a spacious double height foyer with a bridge staircase leading to the circle. The total seating was 2,018. It was renamed ABC during the 1960s and closed in 1973. It became a bingo hall and closed in February 2010. It is listed Grade II and is now a church.

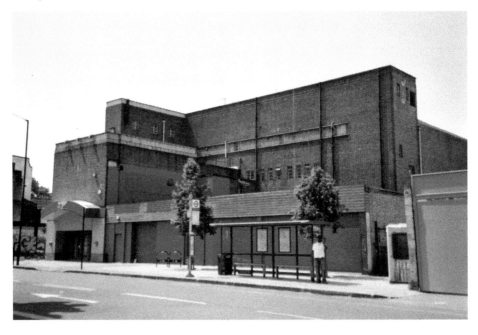

Camberwell New Road

Tramlines in Camberwell New Road were removed after trams ceased running along that road. Robert J. Harley in *Camberwell & West Norwood Tramways* stated that the electric tramway from Camberwell Green to Kennington and Vauxhall opened in 1903. The last tram passing Camberwell Green ran in July 1952. In *Victorian Suburb* H. J. Dyos wrote that within two years of Vauxhall Bridge opening in 1816 Camberwell New Road was cut in place of the tortuous Cut Throat Lane. The Co-operative store was the first in the south east region to be given the new fascia.

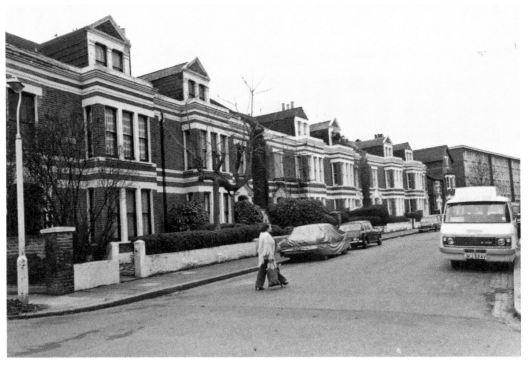

Muriel Spark

Baldwin Crescent was photographed in 1979. Author Muriel Spark lived at number 13 (seen below) from 1955 until 1966. Here she finished writing *The Comforters* and then wrote *Robinson* (1958), *Memento Mori* (1959), *The Ballad of Peckham Rye* (1960) and *The Bachelors* (1960). In *Muriel Spark The Biography* Martin Stannard wrote about the time she lived in Baldwin Crescent and said: 'She loved it, and stayed for eleven years.'

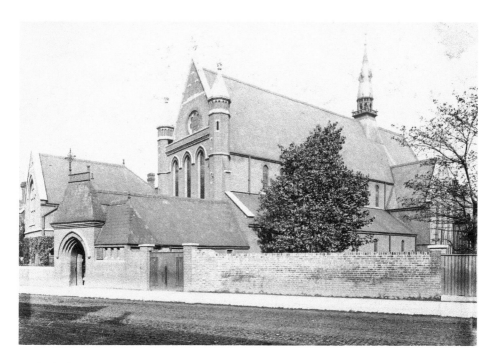

Cathedral

St Mary's Greek Orthodox Cathedral in Camberwell New Road was originally a Catholic Apostolic church. It opened in 1876 with a service that lasted for three hours. The building was very badly damaged during the Second World War but it continued to have a congregation until 1961. The Greek Orthodox Church rented the building two years later. After buying it in 1977 the church became a cathedral so the London Borough of Southwark has had three cathedrals since then.

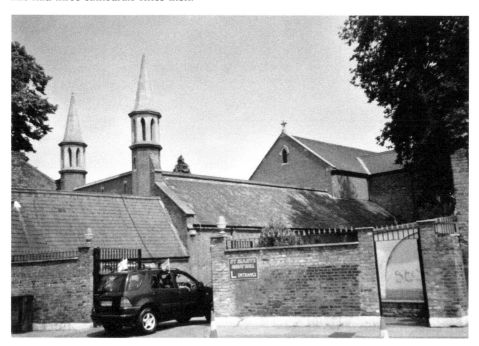

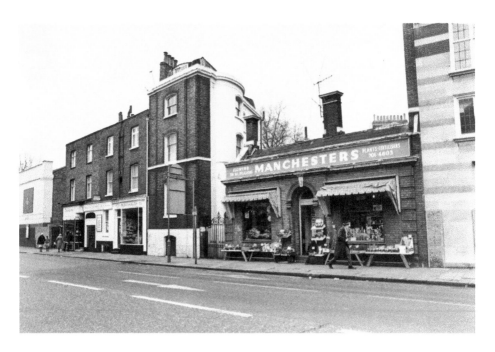

Dispensary

Outside The Old Dispensary pub in Camberwell New Road is a plaque which states: FOUNDED 1862. REBUILT BY VOLUNTARY CONTRIBUTIONS 1880. The building belonged to the Camberwell Provident Dispensary. This was established to assist poor people within a radius of 1¼ miles of St Giles's Church. When they were ill they received medical attention and medicine. There were more than 6,000 members in the 1870s. A leaflet in the Minet Library states: 'This prompt and timely aid afforded by the Dispensary is not only effectual for the cure of disease, but often for arresting it in its early stages.'

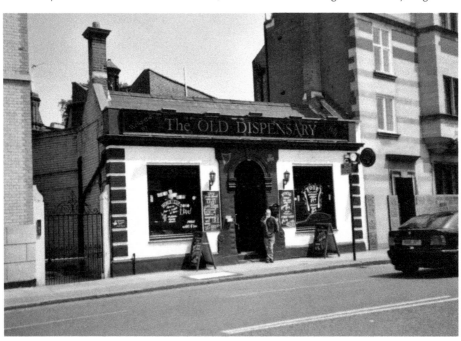

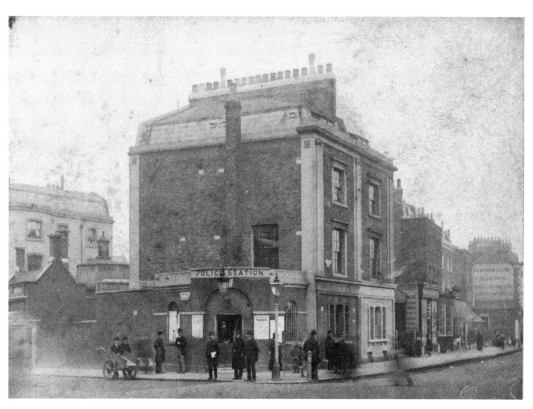

Police Station

A police station used to be on the corner of Camberwell Green and Camberwell New Road where the Camberwell Green Surgery is today. It opened in 1820. During the 1872 police strike the Camberwell sergeants and men refused to go on duty during the night of 16 November. A new police station was opened in 1898 at No. 22 Church Street. The land cost £4,000.

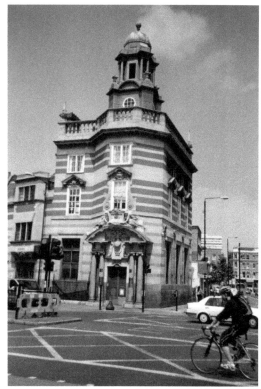

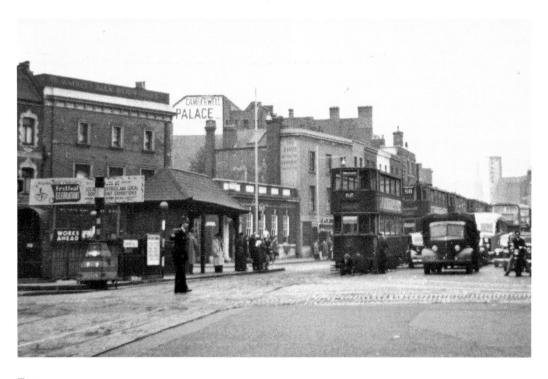

Tram

A broken down tram in Denmark Hill was photographed on 4 June 1951. Camberwell Palace of Varieties was built in 1899 by a company run by the famous comedians Dan Leno and Herbert Campbell. It had 2,000 seats. In 1930, it was equipped to show talkies. The building closed in 1956.

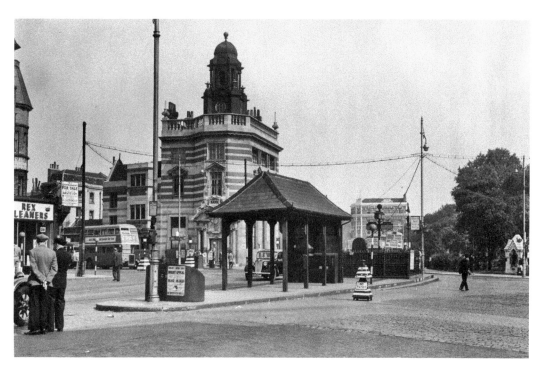

No Trams

This historic photograph was taken on 6 July 1952 – the day after trams ran through Camberwell for the last time. A 185 bus is waiting in Camberwell New Road. The tall building was originally the London and County Bank erected in 1899. It is included in *Public Sculpture of South London* by Terry Cavanagh. Today it is Camberwell Green Surgery.

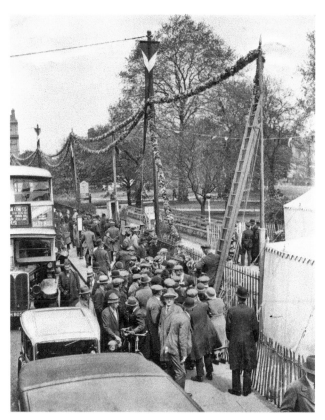

King George V

Preparations were made at Camberwell Green for the visit of King George V and Queen Mary during their royal drive through South London on 18 May 1935 to commemorate the King's Silver Jubilee. Though the style of buses has changed in the last seventy-five years, bus route 35 continues to go through Camberwell and on to Clapham.

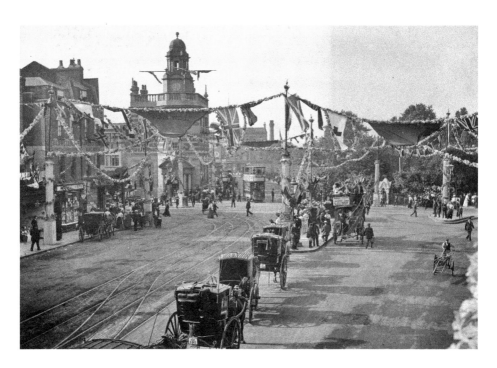

King Edward VII

Tuesday 20 July 1909 was a very special day in Denmark Hill when Their Majesties King Edward VII and Queen Alexandra, accompanied by HRH Princess Victoria, went to lay the foundation stone for King's College Hospital. The *South London Press* reported on 23 July that 'Camberwell-green was literally ablaze with colour and alive with people whose huzzas were again and again renewed as the Royal visitors passed up Denmark Hill. The bells of St Giles's Parish Church, manipulated by the Westminster ringers, pealed forth their music, the Camborough Military Band played selections near the green ...'

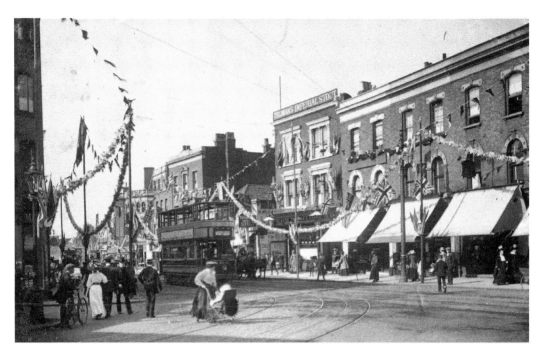

King's College Hospital

Denmark Hill was decorated for the visit of King Edward VII when he laid the foundation stone of King's College Hospital in 1909. Though the postal address of the hospital is Denmark Hill, SE5, it is in the London Borough of Lambeth. *The Story of King's College Hospital* by David Jenkins and Andrew T. Stanway includes a photograph of the junction of Denmark Hill and Coldharbour Lane in 1905 – with a horse-drawn omnibus and also a horse and cart.

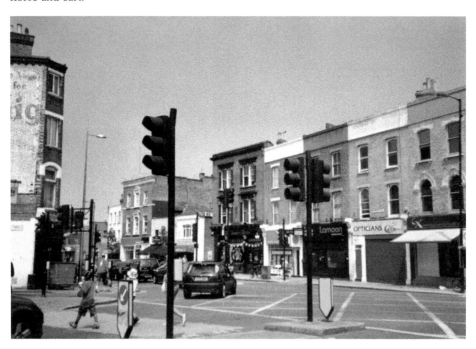

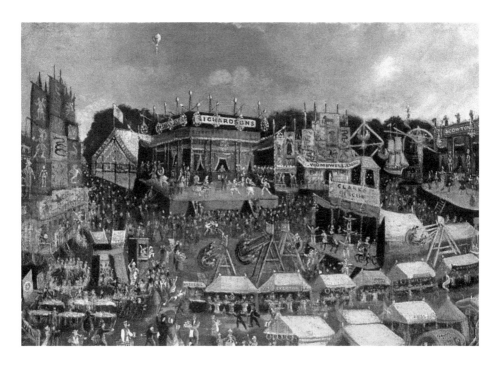

Camberwell Fair

Addington Square Residents Association published copies of Parkhurst's 1861 oil painting of Camberwell Fair. In the Middle Ages, Camberwell Fair was held on Camberwell Green for three weeks. It provided local people with the opportunity to buy goods they could not produce on their own land. In 1857, the Vestry of the Parish of Camberwell bought Camberwell Green from its private owners. Mendelssohn was inspired by Camberwell Green to write his *Spring Song*; its original title was *Camberwell Green*. The composer wrote it while he was staying in 1842 at Denmark Hill with a German family related to his wife.

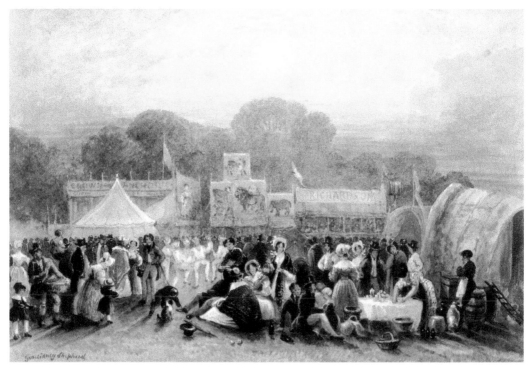

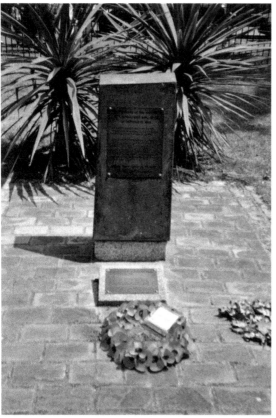

Fair Ended

A painting of Camberwell Fair, in around 1850 by George Sydney Shepherd, is in the Huntington Art Gallery in California. A postcard of it was published by the Camberwell Society. In *Ye Parish of Camerwell*, W. H. Blanch stated that Camberwell Fair was fortunately a thing of the past because for three days in August 'the residents of Camberwell were compelled to witness disgusting and demoralising scenes which they were powerless to prevent'. A memorial stone stands above an air raid shelter where a wedding party were killed on 17 September 1940.

Peabody Trust

Large houses stood on the east side of Camberwell Green before the Peabody Trust built flats there. In 1862, George Peabody (1795-1869) founded the Peabody Donation Fund, providing £500,000 for 'the construction of such improved dwellings for the poor as may combine in the utmost possible degree the essentials of healthfulness, comfort, social enjoyment and economy' for Londoners. Queen Victoria acknowledged this as a gift 'wholly without parallel'.

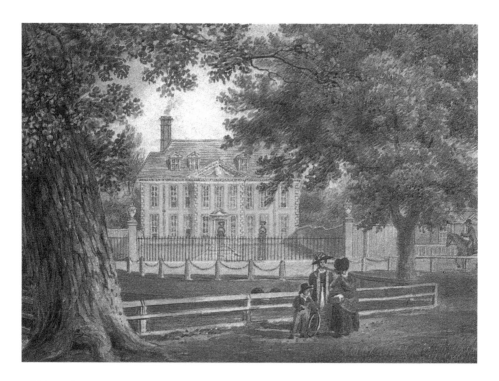

Old Mansion

A fine old mansion at Camberwell Green was painted, *c.* 1820, by local artist J. B. Cuming. It was known for many years as 'The Old House on the Green' and was built in around 1709. It stood on what is now Wren Road. The pond occupied the south east corner of the Green. The house was demolished in 1851/2 to make way for the Congregational Church. The Camberwell Society published copies of the painting.

Dr Harold Moody

This view from Camberwell Green shows the Congregational Church in Wren Road opened in 1853. It was sold in 1960 and its proceeds were used to build Camberwell Green United Reformed Church in Love Walk. Flats in Wren Road called The Colonnades were built on the site of the nineteenth-century church. One of the members of Camberwell Green Congregational Church was Dr Harold Moody; an English Heritage Blue Plaque commemorates him at 164 Queen's Road, Peckham. See *Peckham and Nunhead Through Time* (pages 32, 36 and 76). Dr Moody's bust is on display in Peckham Library.

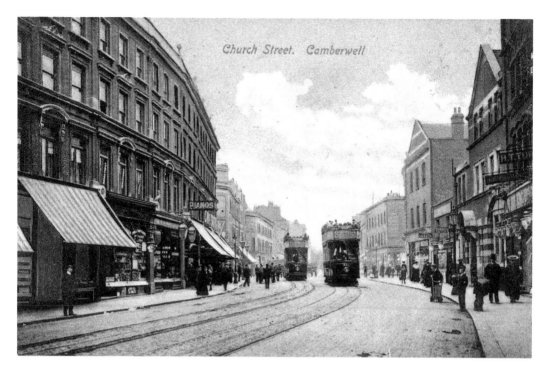

Church Street. Camberwell

Church Street

Church Street had trams running along it until 1952. The mode of public transport has changed since then, but the road continues to be a busy route to and from Peckham. *Camberwell & West Norwood Tramways* by Robert J. Harley tells the story of trams in the Camberwell area and has many photographs of scenes long gone.

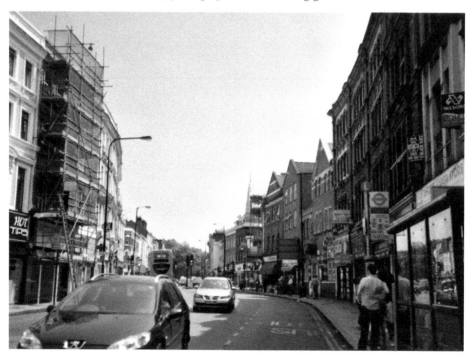

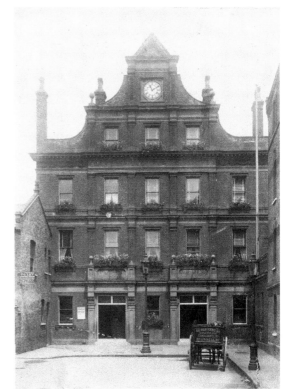

Camberwell Baths

Camberwell Baths were opened in 1892 by the Lord Mayor of London. The *South London Press* reported: 'The Chief Magistrate of the City and his attendant bodyguard descended upon Camberwell amid quite a glow of civic brilliance. The blare of brazen instruments, the prancing and curvetting of sleek City horses, gorgeous equipages, ornately-attired footmen, flags and banners – flying very limp and damp in the moisture-laden air – all tended to lend animation and picturesqueness to the gay scene, while the march of the armed men was sweet music to those who dote upon the military.' In 2010, Camberwell Leisure Centre is undergoing a major refurbishment programme.

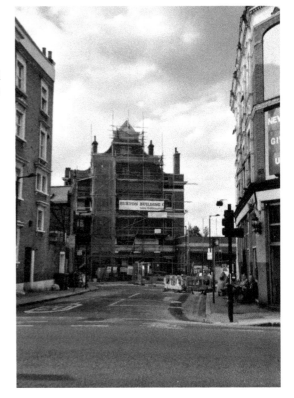

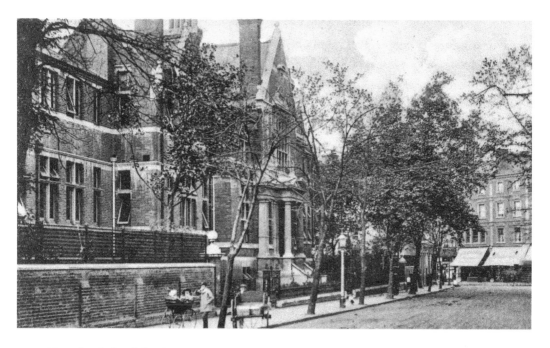

Mary Datchelor School

Mary Datchelor School in Grove Lane was opened in 1877; it stood on the site of a medieval manor house that had a history dating back to the time of the Domesday Book in 1086. During the eighteenth century, three sisters – Mary, Beatrix and Sarah Datchelor – left money to the 'poor inhabitants' near their home in the City of London. By the next century the area was prosperous so no longer needed the bequest. Consequently, the Datchelor Trust was allowed to establish a girls' school in Camberwell with £20,000 from the bequest. The school closed in 1981 and has recently been converted into apartments.

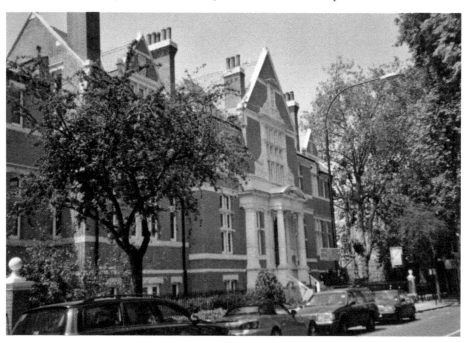

Milk Depot

A Royal Arsenal Co-operative Society milk depot occupied a site in Grace's Mews off Camberwell Grove. Housing now occupies the land. In 1970 the author of this book spent five weeks employed as a milkman based here. He drove a milk float to Bermondsey. At 6.30 every morning he took a truck loaded with six crates to the top of Maydew House, a very tall residential block overlooking Southwark Park. Some of his experiences as a milkman are included in *Bermondsey & Rotherhithe Remembered* by Stephen Humphrey.

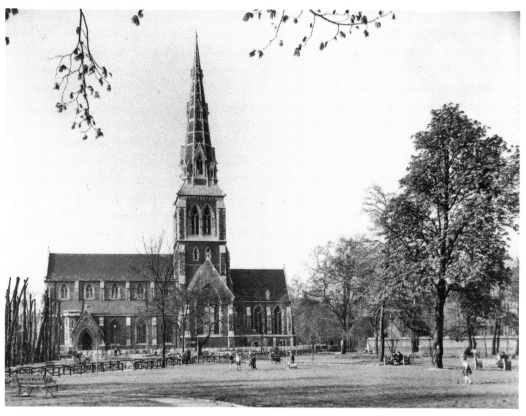

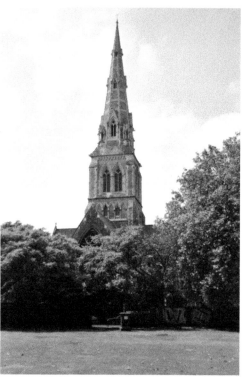

St Giles's Church

St Giles's Church was consecrated in 1844.
It was designed by Sir George Gilbert Scott
who was the architect of St Pancras Hotel
and the Albert Memorial. The organ was
made by J. C. Bishop, founder of a firm of
organ builders. It was designed by Samuel
Sebastian Wesley, grandson of hymnwriter
Charles Wesley, who had been organist
at the old St Giles's Church which was
destroyed by fire in 1841. Historian Mary
Boast wrote *St Giles: the Parish Church of
Camberwell*.

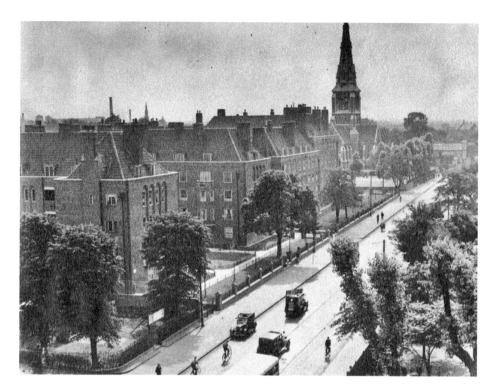

Roof View

St Giles's Church was photographed from the roof of Camberwell Town Hall in 1934 and from the same roof in 2009, but the building became Southwark Town Hall in 1965. That was because in that year the Metropolitan Borough of Camberwell joined with the Metropolitan Boroughs of Bermondsey and Southwark to become the London Borough of Southwark.

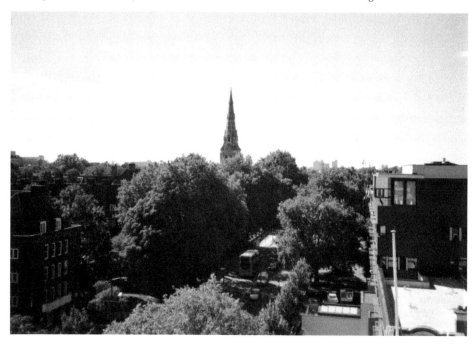

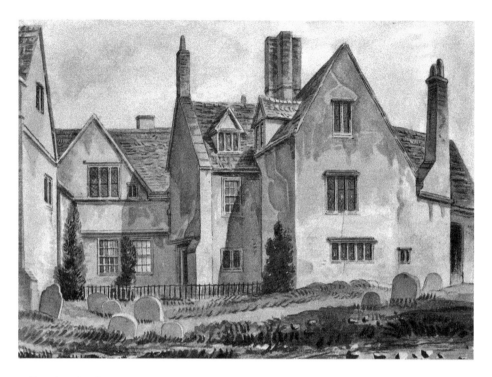

Wilson's School

Wilson's Annexe of Camberwell College of Arts in Wilson Road used to be Wilson's Grammar School which opened in 1882. Camberwell's first known school previously used a building painted in 1824. The school was founded under Royal Charter in 1615 by Edward Wilson. He was Vicar of St Giles's and wanted to give local boys, including twelve children who had poor parents, such a knowledge of Latin and Greek as would enable them to go to a university so they could enter either the clerical or one of the learned professions.

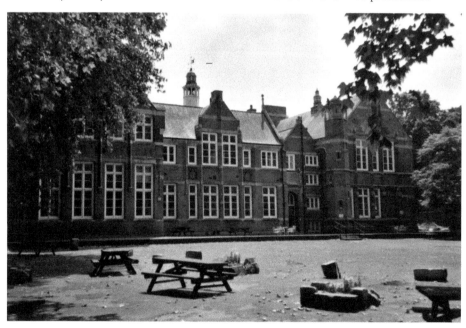

Elmington Road

Elmington Road, formerly called Waterloo Street, was photographed in 1934. A horse and a bicycle were the means of transport – in sharp contrast to 2010! Elmington Estate, between Camberwell Road and Southampton Way, was a large area cleared and redeveloped by the London County Council with tower blocks. It has about 700 dwellings. All the blocks are named after poets, in honour of Robert Browning who was born in Camberwell.

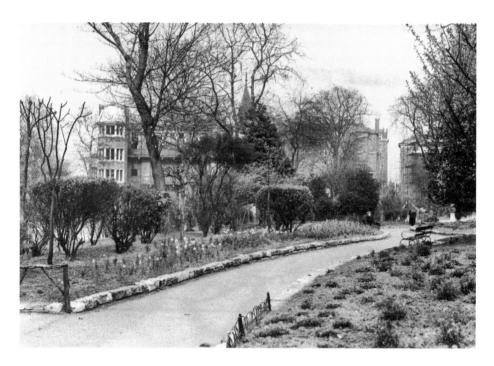

Brunswick Park

Brunswick Park was opened by the Mayor of Camberwell in 1907. It had previously been a private garden maintained by residents who lived in surrounding houses. It is probable that the park formed a portion of the sixty-three acres of meadow land mentioned in the Domesday Book as being attached to St Giles's Parish Church. In 1937, two hard tennis courts and a children's playground were made. A blue plaque commemorating Una Marson who lived in a house overlooking the park, at number 17, was unveiled in 2009. She was the first black female programme maker at the BBC.

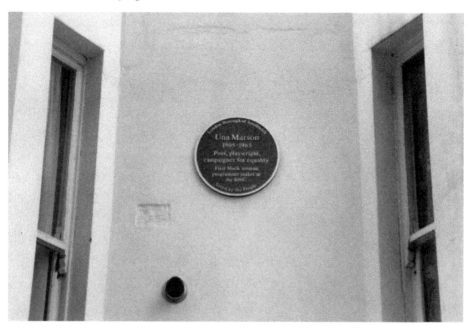

Aged Pilgrims' Asylum

The first stone for the Aged Pilgrims' Asylum was laid on 16 October 1834 and it was completed in 1837. The almshouses were built for the Aged Pilgrims' Society founded in 1807. They accommodated '42 aged pilgrims'. These were elderly Christians who had a low income. The flats in Sedgmoor Place are now called Pilgrims Cloisters and have been private flats since 1992. A history of the Aged Pilgrims' Friend Society called *Inasmuch* was written by the Society's Secretary, John E. Hazelton, in 1922. It can be seen in the highly acclaimed Southwark Local History Library.

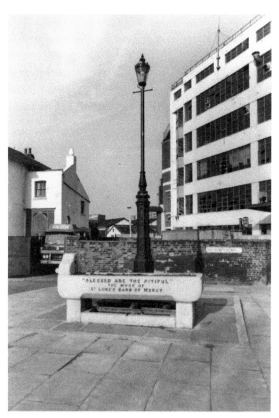

Horse Trough

A horse trough seen here in Southampton Way in 1982, with the Samuel Jones gummed paper factory on the right, was provided by the Metropolitan Drinking Fountain & Cattle Trough Association. The cover of *Peckham Society News* (Spring 2003) showed a drawing of the horse trough by Stuart Brown who wondered why it had disappeared. In the next issue of the magazine, Camberwell Councillor Ian Wingfield stated that it had been stolen. Unfortunately, it has never been found. If anyone knows the whereabouts of the horse trough please inform the author of this book.

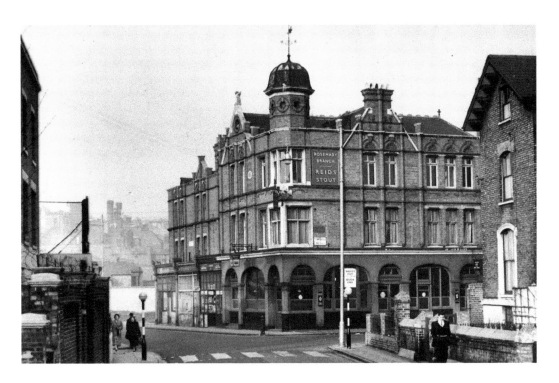

Rosemary Branch

Stephen Lawrence House and other homes close to the corner of Southampton Way and Commercial Way stand where the Rosemary Branch Tavern and its extensive grounds were in the nineteenth century. In *Ye Parish of Camerwell* W. H. Blanch wrote that it was 'a well-known metropolitan hostelrie half a century ago'. The picture above shows the last pub to be built on the site. In the 1890s the Rosemary Branch was a popular music hall.

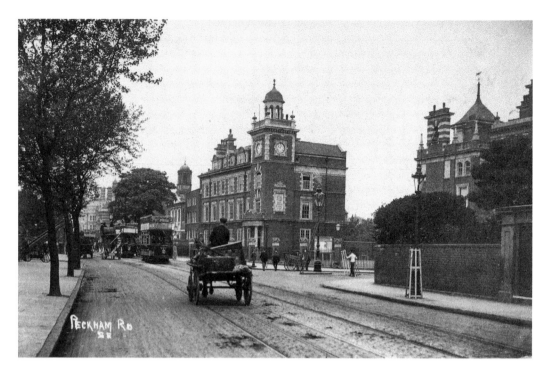

Oliver Goldsmith School

Horse buses and electric trams travelled along Peckham Road in the early part of the twentieth century. Peckham Road School, now Oliver Goldsmith Primary School, was built in 1899. A memorial to Damilola Taylor (1989-2000) is in the grounds of the school. He was a Nigerian boy who was a pupil at the school. Damilola Taylor's murder in north Peckham received huge national publicity.

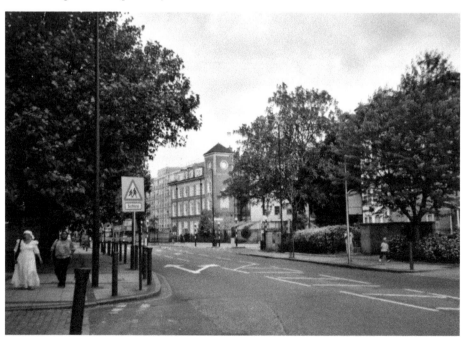

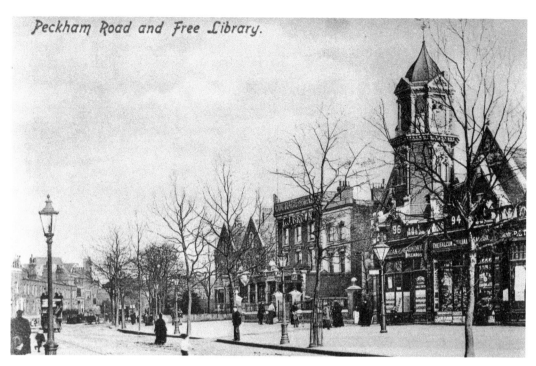

Peckham Road and Free Library.

Camberwell Central Library

Camberwell Central Library in Peckham Road occupied the site where Kingfisher House is today. It was opened in 1893 by the Prince of Wales who became Edward VII after his mother, Queen Victoria, died. The architect was Robert Whellock who designed three buildings that still exist – the former Livesey Museum, Nunhead Library and the former Central Hall in Peckham High Street. The library was bombed during the Second World War. For decades, Camberwell residents have had a library only the size of two shops. It is likely to be many years before Camberwell has one as prestigious as Peckham's.

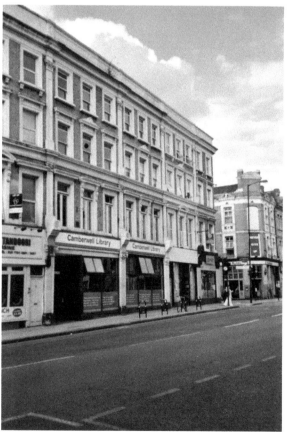

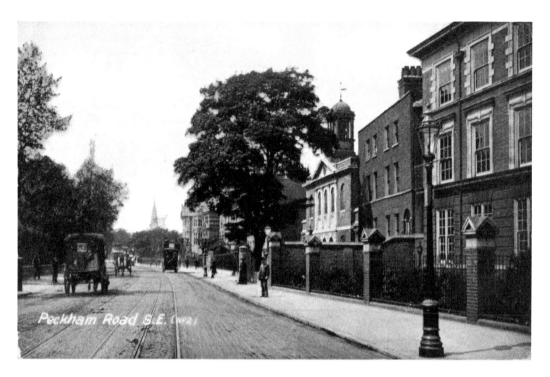

Peckham Road

This early twentieth-century view of Peckham Road shows Peckham Road School (now Oliver Goldsmith Primary School), Camden Chapel, the South London Gallery and the spire of St Giles's Church.

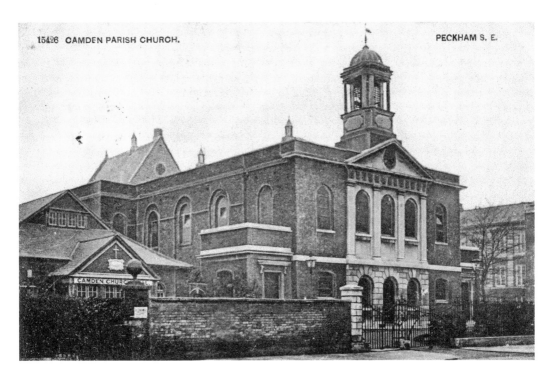

Camden Chapel

Camden Chapel in Peckham Road was built in 1797. Writer and art critic John Ruskin had a pew quite near the pulpit and he helped to design an extension to the building. An 1873 drawing and a potted history are included in *Ye Parish of Camerwell* by W. H. Blanch. The chapel was badly damaged during the Second World War. Voltaire was built on the site.

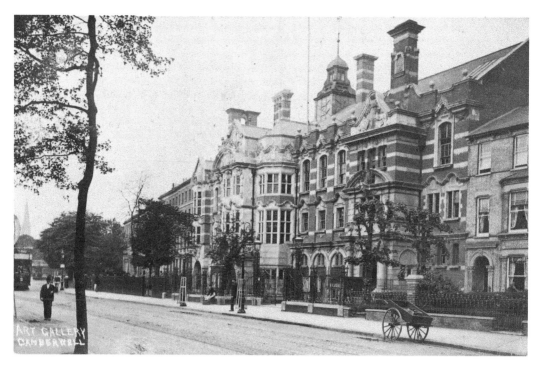

South London Gallery

The South London Gallery in Peckham Road was built to house a collection of paintings by eminent artists. It opened in 1891. Paintings were largely donated by the artists themselves or by wealthy benefactors. One of the Gallery's aims was to enable working people to have the opportunity to see the best art being produced. The story of the Gallery is told in *Art for the People* edited by Giles Waterfield.

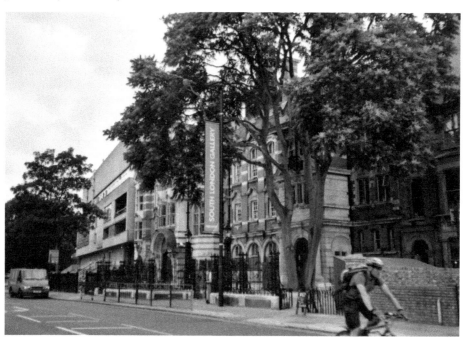

Sceaux Gardens

Sceaux Gardens, seen above in 1968, was opened on 16 May 1959. This new council estate was built in the grounds of Camberwell House, residential accommodation for mentally ill people. The development was named after a suburb of Paris with which Camberwell had a friendship link. The Mayor of the French Sceaux opened the estate – seen below from the roof of Southwark Town Hall.

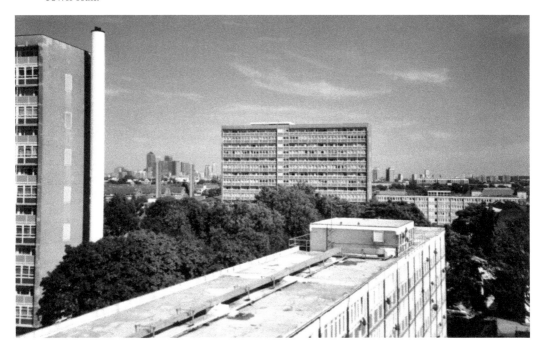

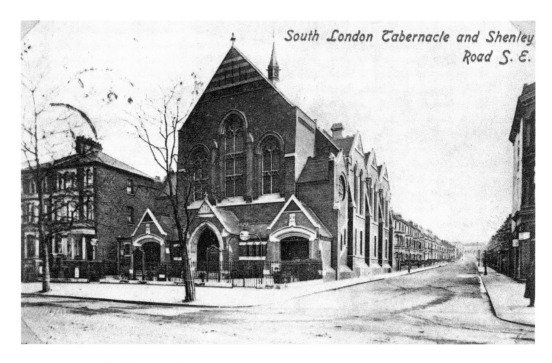

South London Tabernacle and Shenley Road S.E.

South London Tabernacle

South London Tabernacle in Peckham Road, at the corner of Shenley Road, is included in *The Baptist Churches of Surrey* edited by Arthur H. Stockwell (published in 1910). The first service was held on 31 December 1884. After the church was demolished in the late twentieth century Welton Court, sheltered accommodation for elderly people, was built on the site. The congregation now meet in Welton Hall, Bushey Hill Road. A booklet to celebrate the church's centenary was published in 1980; it can be seen in Southwark Local History Library.

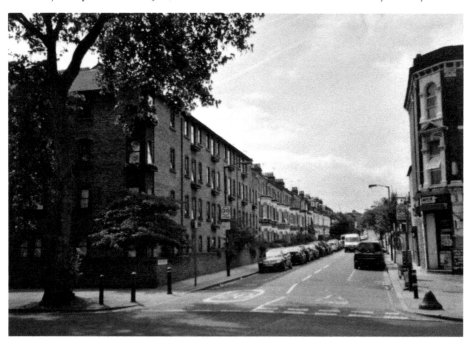

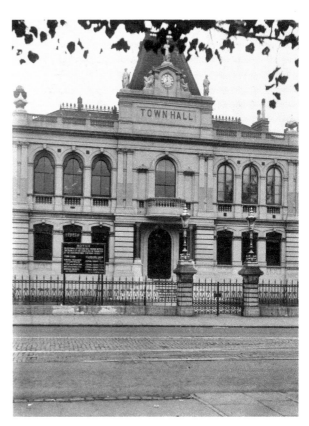

Camberwell Town Hall

The picture above shows Camberwell Town Hall before it was enlarged in 1934. Southwark Town Hall in Peckham Road SE5 was the Town Hall for the Metropolitan Borough of Camberwell until 1965. It incorporates the Vestry Hall built in 1872/3. The present Council Chamber is the main part of the Victorian building from which the affairs of the parish of St Giles were run in the nineteenth century. The picture below shows a Camberwell Community Council meeting in 2010.

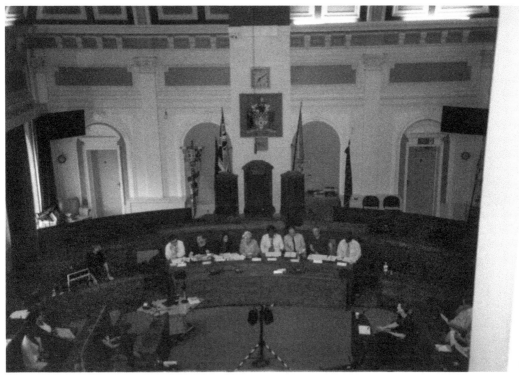

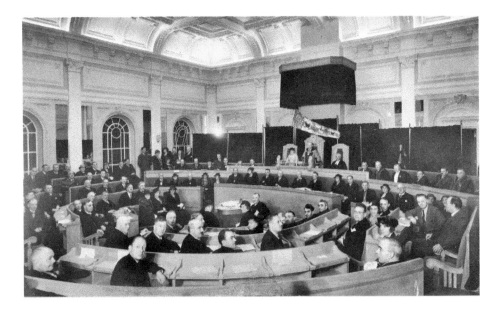

Town Hall Opening

The above picture shows the councillors in Camberwell Town Hall on the day it opened – 10 October 1934. Two days later, the *South London Press* reported the event with the heading: 'CAMBERWELL'S £50,000 TOWN PALACE First Municipal Hall Cost £500!' The newspaper stated: 'In the glittering hall of mirrors, which was once the old Council Chamber, the mayor (Cllr. S. E. Hall) told the assembled company how Camberwell had grown from a parish which held its earliest vestry meetings in a workhouse or the local taverns.' The mayor declared the Town Hall open for official business and added: 'May heaven prosper all those who work therein for the welfare of citizens.'

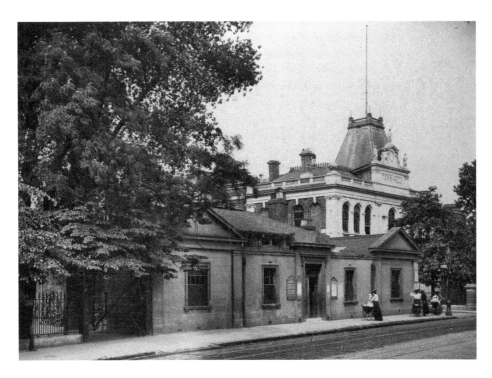

Old Vestry Hall

What became known as the Old Vestry Hall was built in 1827. It was very hot in summer and particularly draughty in winter. The New Vestry Hall opened in 1873. This became Camberwell Town Hall when Camberwell Borough Council was formed in 1900. This was incorporated in a new Town Hall that opened in 1934. The Council of the London Borough of Southwark meets in the main part of the 1873 Vestry Hall.

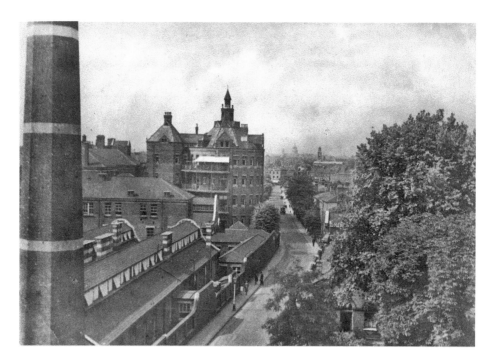

Havil Street

Havil Street was photographed from the roof of Camberwell Town Hall in 1935. A picture was taken from the same position in 2009. St Giles's Hospital, formerly Havil Street Infirmary, is the most prominent feature. In *The Story of Camberwell* Mary Boast wrote that in Havil Street there is a very unusual round tower in cream coloured brickwork, five storeys high. 'This is St Giles's Tower, now converted into eighteen private flats. It was built, in 1888, for quite a different purpose. It was a ward block of St Giles's Hospital'.

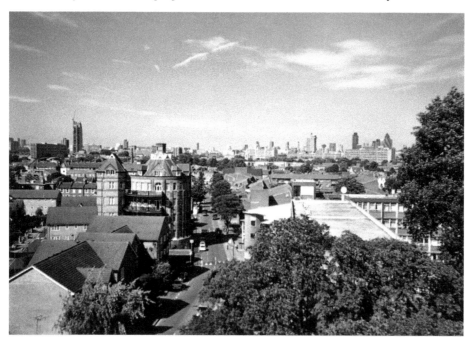

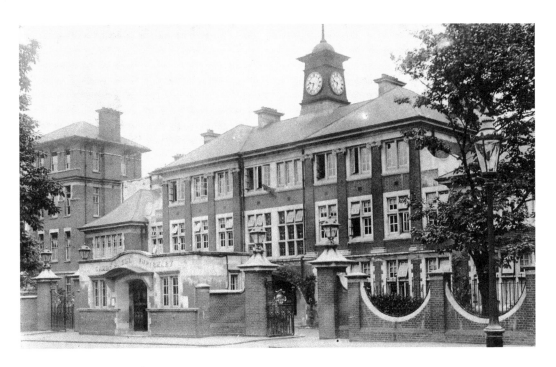

St Giles's Hospital

St Giles's Hospital had its origins in an eighteenth-century workhouse in Workhouse Lane, now called Havil Street. After that was demolished a larger workhouse was built at the rear of the old site and an infirmary was added. This later became St Giles's Hospital and much of the building is still in use as apartments and for other purposes.

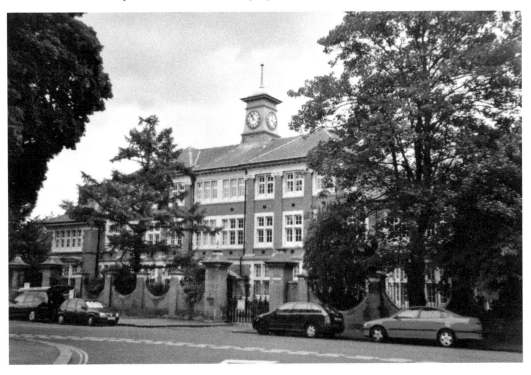

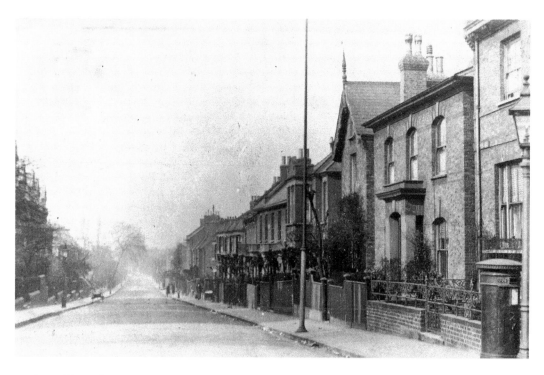

Bushey Hill Road, seen here in *c.* 1912, is a reminder of an old field name. When the road was surveyed in 1899 for the second edition of Charles Booth's famous inquiry *Life and Labour of the People in London* it was reported that 'Nearly all the detached houses shown on the map have given way to smaller dwellings. Occasional servants.'

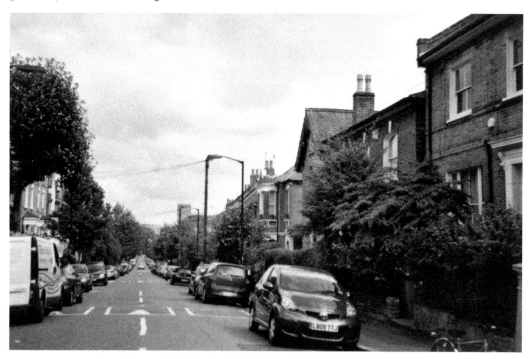

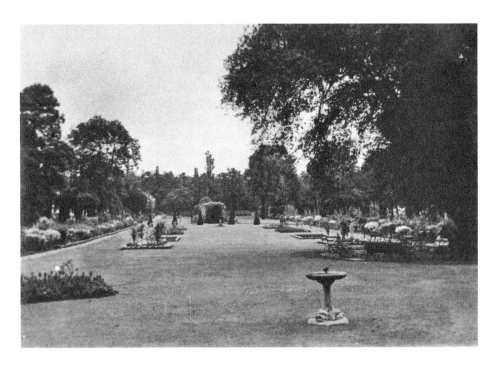

Lucas Gardens

Lucas Gardens were opened on 28 July 1955 in the grounds of a former lunatic asylum called Camberwell House, seen here in 1934. They were officially opened by the chairman of the London County Council, Norman Prichard. A campaign was organised in 2009 to prevent Southwark Council from selling part of Lucas Gardens to a private developer. Thankfully the campaign was successful because all the open green spaces in Camberwell are important for the mental and physical health of local people. Lucas Gardens were named after Alderman James Lucas who died in office as Mayor of Camberwell in April 1955.

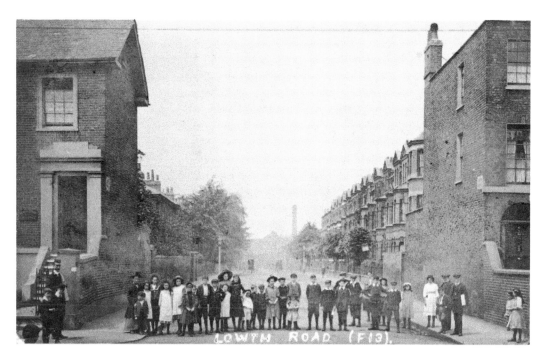

Lowth Road

Children gathered in Lowth Road to have their photograph taken. In *The Streets of London: The Booth Notebooks* the 1899 survey showed that the road had two and three storey houses. There were new flats at the south east end. The residents were fairly comfortable and had good ordinary earnings. The road was named after Robert Lowth (1710-87). He became Bishop of London in 1777.

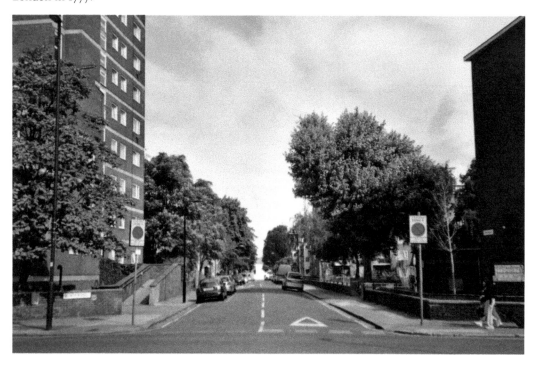

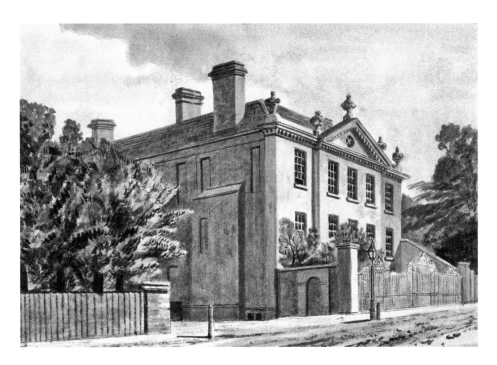

Champion Lodge

Champion Lodge in Denmark Hill, seen here in 1827, was the residence of Sir William de Crespigny. He succeeded his father Sir Claude de Crespigny, who was created a baronet in 1805, a year after His Royal Highness the Prince of Wales honoured Champion Lodge with a visit. Champion Lodge was pulled down in 1841. The original painting of Champion Lodge by J. C. Buckler is in Lambeth Archives, 52 Knatchbull Road, SE5. Champion Lodge is shown on Greenwood's 1830 map. It was close to where Love Walk is today.

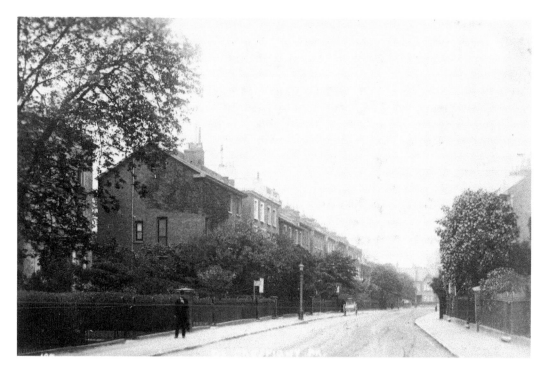

De Crespigny Park

De Crespigny Park was an attractive residential road in the early part of the twentieth century. In his novel *In the Year of Jubilee*, published in 1894, George Gissing wrote about houses belonging to the ambitious middle class people of Camberwell – houses like those in De Crespigny Park where 'each house seems to remind its neighbour, with all the complacence expressible in buff brick, that in this locality lodgings are *not* to let.' Today, the highly acclaimed Institute of Psychiatry is based there.

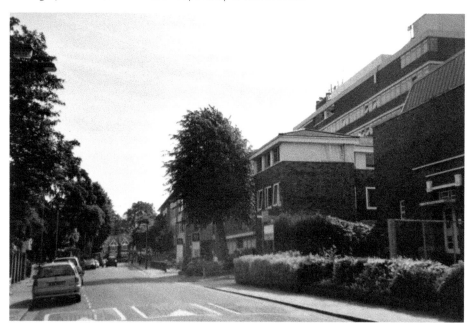

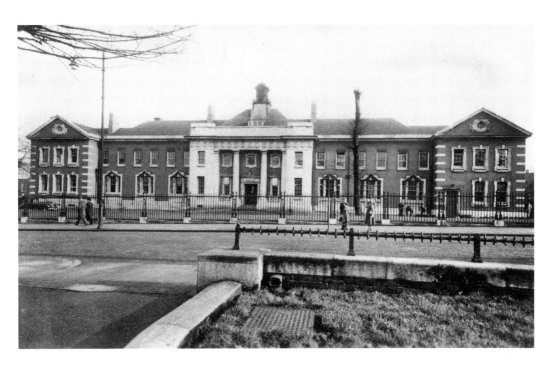

Maudsley Hospital

Dr Henry Maudsley, a doctor eminent in the field of mental health, donated to the London County Council a large sum of money for a small hospital with research facilities. The Maudsley Hospital at Denmark Hill opened in 1923. The story of the world famous and highly regarded hospital is told in *Scenes from Bedlam: A History of Caring for the Mentally Disordered at Bethlem Royal Hospital and the Maudsley* by David Russell.

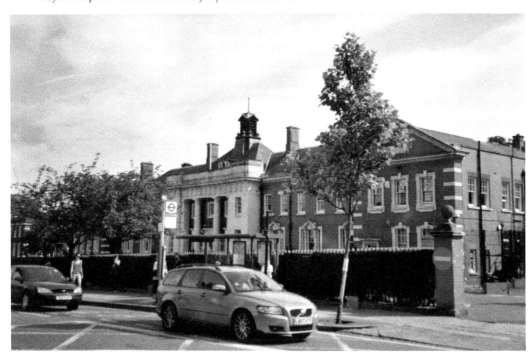

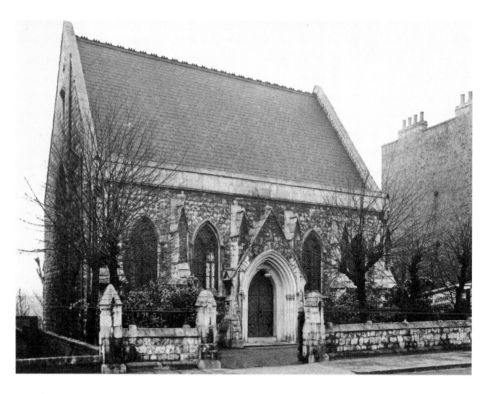

Windsor Walk

Beresford Chapel in Windsor Walk, photographed in 1953, was used from the 1920s by Open Brethren. It was originally a German Lutheran church opened in 1855. Services were conducted entirely in German. The church was vacated by the German congregation in 1914, the year in which the First World War began. The first reference to Germans in Camberwell was in a curious pamphlet published in 1710 called *The State of the Palatines for fifty years past to this present time*. It is one of the oldest items in Southwark Local History Library.

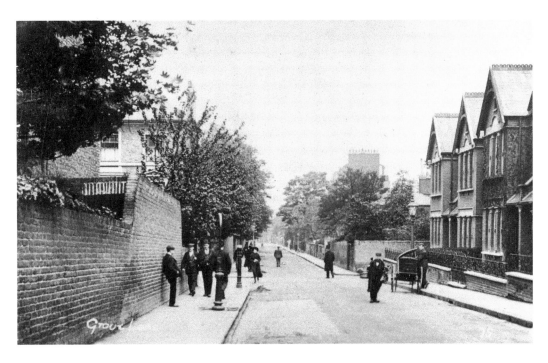

Grove Lane

In the eighteenth century, Grove Lane was called Dog Kennel Lane. In 1874, Edward Pinder, Churchwarden at St Giles's, lived at Wilby Lodge in Grove Lane and Walter Charles Mulley, an Overseer of the Poor, lived at number 38. In 1875, a Mr Barrett owned a mineral water factory in Grove Lane.

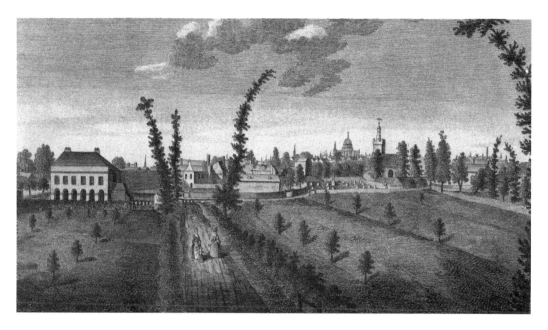

Camberwell Hall

Camberwell Hall in Grove Lane, now a private residence, was built in 1748 as a tavern. In the nineteenth century, it was much used as a meeting place for religious, social, political and parochial purposes. In its early days it formed part of a public place of entertainment known as Grove House, a famous country tavern that was well patronised by young people from the City of London. In those days there were extensive gardens surrounding the house.

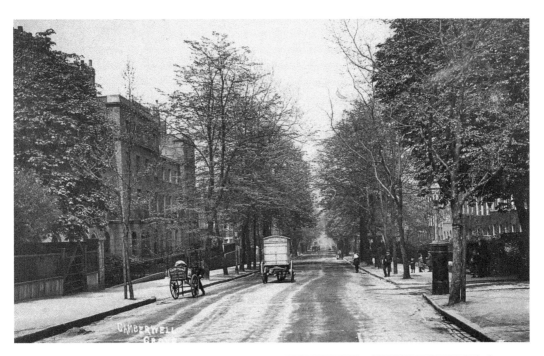

Camberwell Grove

Camberwell Grove, seen above in around 1912, was the birthplace of statesman Joseph Chamberlain (1836-1914); he was born at number 188 (photographed in 2010). The building up of Camberwell Grove began after 1776 when the Manor of Camberwell Buckingham was sold and the old manor house was demolished. This opened up the entrance to the Grove from Camberwell Church Street, making it a public road.

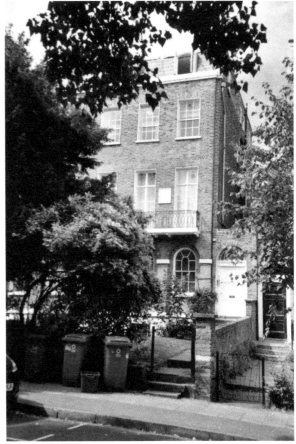

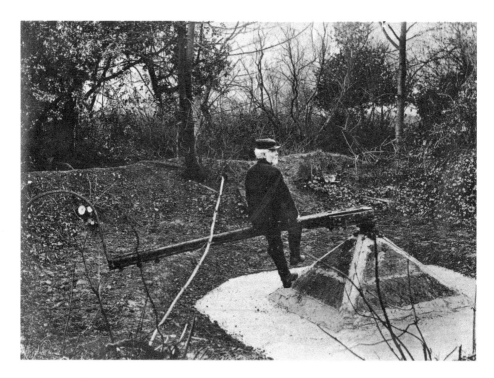

Camber Well

In *The Story of Camberwell* Mary Boast wrote: 'There were many wells in old Camberwell. One on the site of 56 Grove Park was believed by some to have been the special "Camber Well". It was in use until about 150 years ago with a donkey going round drawing up the water.' A feature on the well was included in *Camberwell Quarterly* (Spring 2009). Part of the well is still visible from the lawn surrounding it.

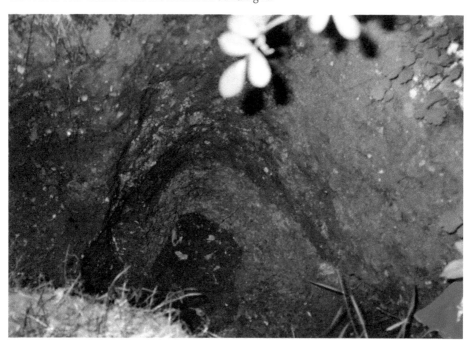

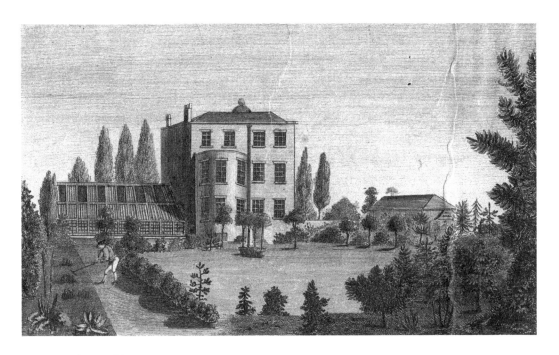

Dr John Coakley Lettsom

Grove Hill, a mansion and estate at the top of Camberwell Grove, was where Dr John Coakley Lettsom lived from 1779 to 1810. He was born in the West Indies but educated in England. He grew rich through treating patients in the West Indies and London. He was a Quaker who was noted for his generosity and kindness to poor people. Part of Dr Lettsom's land that has not been built on is Lettsom Gardens, between Grove Park and Grove Hill Road. It is a haven for wildlife. Grove Hill Villa is shown on Greenwood's 1830 map.

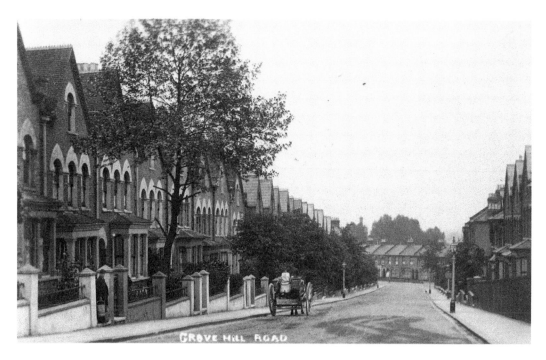

Grove Hill Road

Grove Hill was the name of the mansion and estate where Dr John Coakley Lettsom lived. In *Camberwell Place and Street Names and their Origin* Leslie S. Sherwood stated that Grove Hill Road was given its name because it bordered the estate. The horse and cart, photographed in the early part of the twentieth century, contrast with today's traffic and parked cars. When the road was surveyed in 1899 the occupants were clerks, travellers, a schoolmaster and a solicitor; about half kept servants.

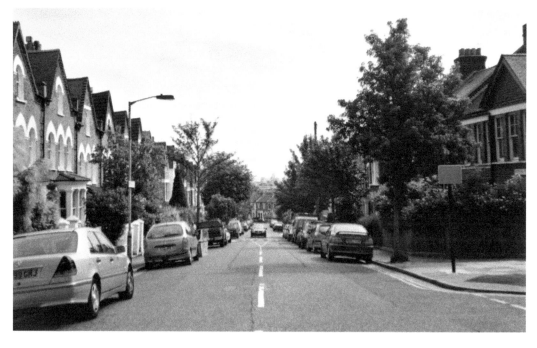

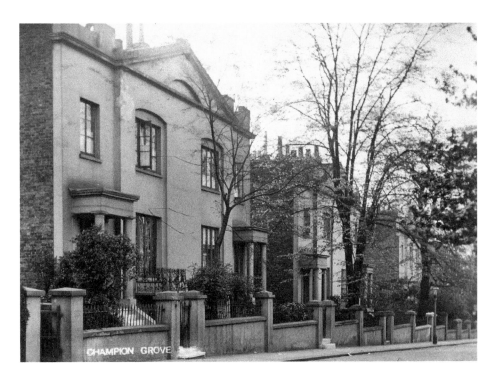

Champion Grove

Champion Grove, seen here in *c.* 1912, takes its name from Sir Claude Champion de Crespigny and family who were local landowners. The De Crespignys appear in local records in around 1740. The family were refugees from France in the reign of King William. In *Ye Parish of Camerwell* W. H. Blanch wrote: 'In Marylebone churchyard are some memorials of the family bearing date 1695.'

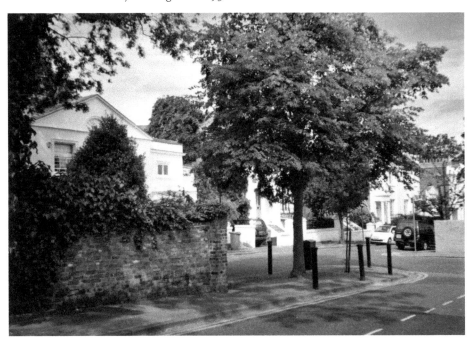

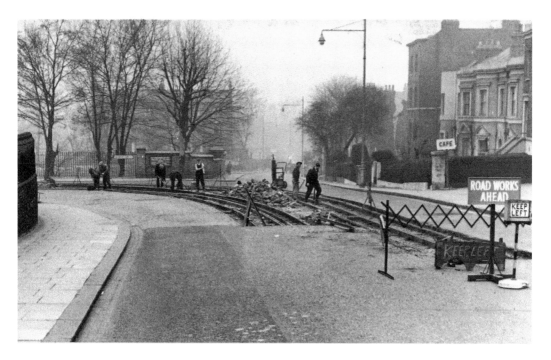

Animals

In the early 1950s, tram tracks were removed at the junction of Grove Lane and Champion Park. In 2009, animals created by sculptor Leigh Dyer were installed in this part of Camberwell. The story was told in *Southwark News* on 5 March 2009 and in the *South London Press* the following day. The Grove Lane Tenants' and Residents' Association successfully secured the necessary cash for the sculptures from the Camberwell Community Council's Cleaner Greener Safer fund.

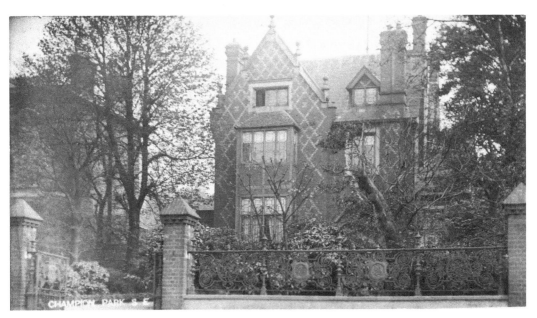

Champion Park

This is one of the nine detached houses in Champion Park. *The Streets of London: The Booth Notebooks – South East* states: 'Large detached houses at east end. Strong, Chairman of LCC living here.' *Achievement: A Short History of the London County Council* by W. Eric Jackson lists Richard Strong, a Progressive, as serving as the LCC member for North Camberwell from 1889 until 1904. He was an Alderman for three years after that. The houses were demolished so William Booth College could be built; that is undergoing a major refurbishment programme in 2010.

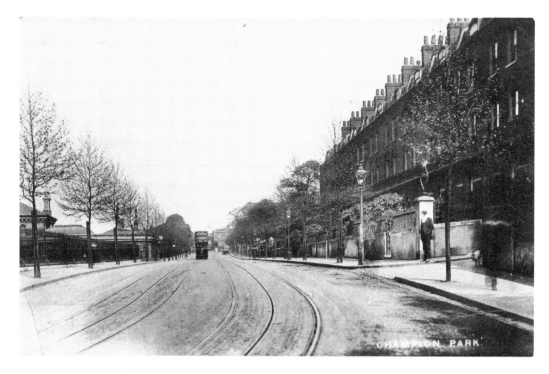

Terrace Demolished

These nineteenth-century houses in Champion Park were demolished in the 1920s to make way for William Booth College. The small road on the right was called Grove Place on the 1871 Ordnance Survey Map and Denmark Hill on the 1894 map. The houses had long back gardens. Beyond this terrace were nine detached houses with gardens twice the length of the gardens at the rear of the terraced houses. They too were demolished so the Salvation Army's training college could be built. See how the London Plane trees have grown!

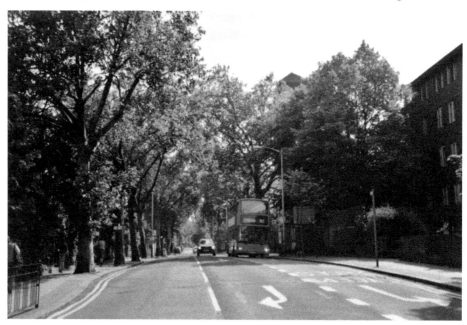

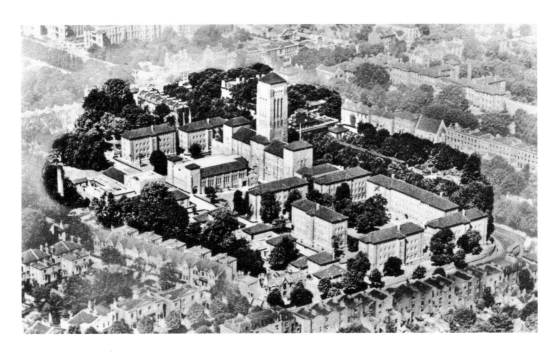

William Booth College

The tower of William Booth College can be seen many miles away from Denmark Hill. Unfortunately, it was not finished for the opening of the college in 1929 which was 100 years after the founder of the Salvation Army, William Booth, was born. Sir Giles Gilbert Scott was the college's architect. He also designed Waterloo Bridge, the present Liverpool Anglican Cathedral, Battersea Power Station, Bankside Power Station (now Tate Modern) and Britain's traditional red telephone box. The tower of William Booth College, and the spire of St Giles's Church, can be seen from Burgess Park.

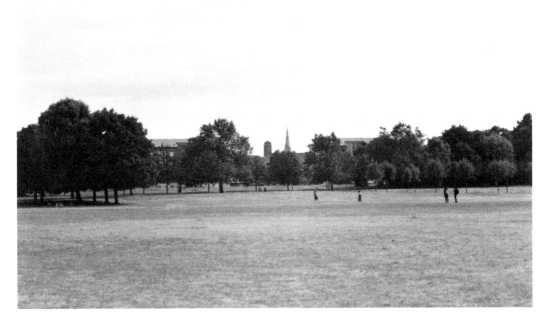

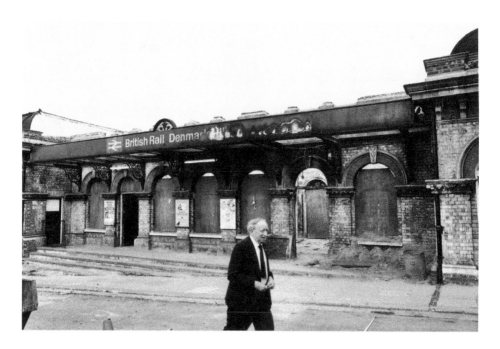

Denmark Hill Station

Denmark Hill Station was set alight in 1980 by vandals who were never caught. It was opened in 1866 to serve mainly as a commuter station on the line between Victoria and London Bridge stations. A major campaign is taking place to try to prevent the closure of the South London Line which has had trains running direct between these two major London termini since 1867. Valerie Shawcross, London Assembly Member for Lambeth & Southwark, spoke on 26 June 2009 in support of people campaigning to retain the threatened South London Line.

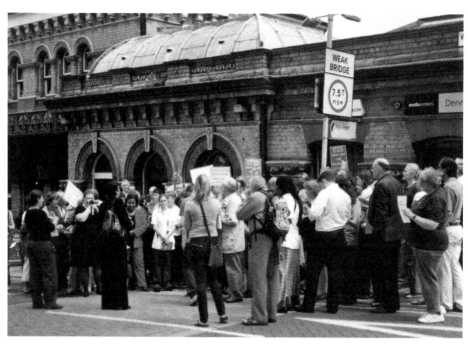

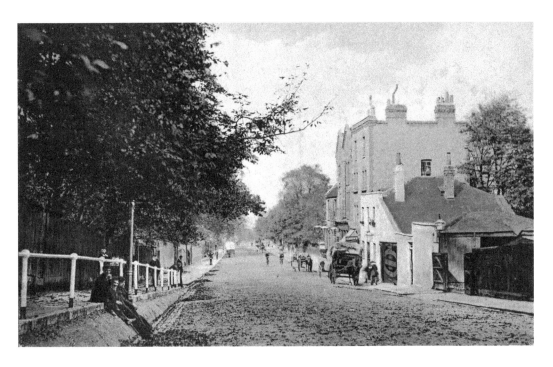

Denmark Hill

This rural scene shows Denmark Hill early in the twentieth century. On the right are the premises of Jones & Sons. They were job masters – people who let out horses and carriages by the job. The view is from near the junction with Champion Hill. Ruskin Park is on the left. The park was opened in 1907 and is now in the London Borough of Lambeth. Writer John Ruskin (1819-1900) lived in a large house on Denmark Hill.

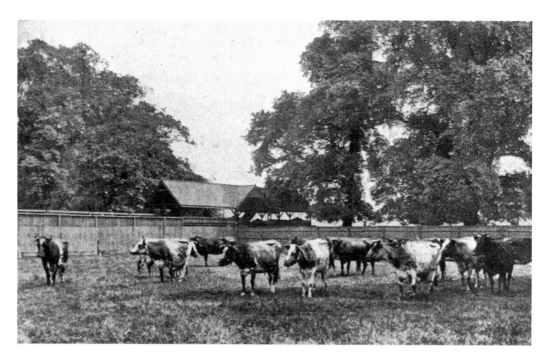

Cows

Cows were kept at Champion Hill in *c.* 1905. The Platanes, seen below, was the headquarters of the local RAF Balloon Command during the Second World War. Barrage balloons were a familiar sight; they were put up to intercept low-flying aircraft. In *The Story of Camberwell* Mary Boast wrote: 'Camberwell suffered especially in the Blitz of 1940-41 and then again in 1944-45, the period of the V1s, the flying bombs, or doodlebugs, and the V2s, the silent rockets.'

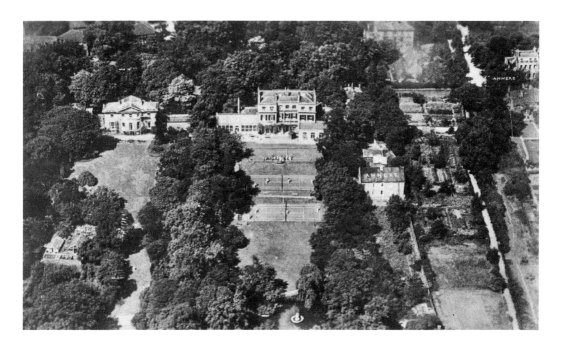

Cleve Hall

Cleve Hall in Champion Hill was a hotel. It was one of a number of impressive residential buildings in this fashionable part of Camberwell. Champion Hill Station opened in 1868; the name was changed to East Dulwich Station in 1888. When Charles Booth added to his famous survey in 1899, Champion Hill was described as having 'Large houses with grounds and stables attached. Mostly old houses but on south side an old house has been pulled down and new detached red-brick houses erected. City merchants and other well-to-do. None with less than four servants. Large number of Germans.'

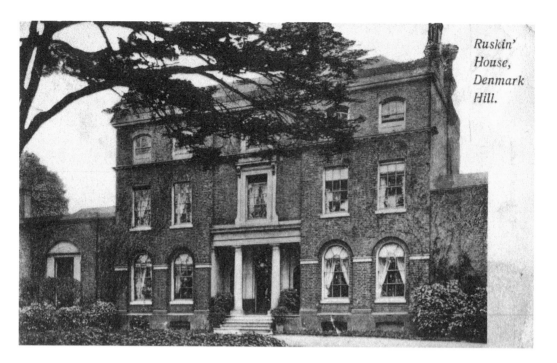

Ruskin' House, Denmark Hill.

John Ruskin

Writer and artist John Ruskin (1819-1900) lived in this large house at 163 Denmark Hill which his father bought in 1842. John lived there until 1872. He described the view from the breakfast-room into the field as 'really very lovely'. In his autobiography *Praeterita* he wrote: 'we bought three cows, and skimmed our own milk, and churned our own butter'. The house was demolished at the end of the 1940s to make way for the London County Council's Denmark Hill Estate. The house stood at the corner of where Cross Court and Blanchedown are today. James S. Dearden wrote *John Ruskin's Camberwell*.

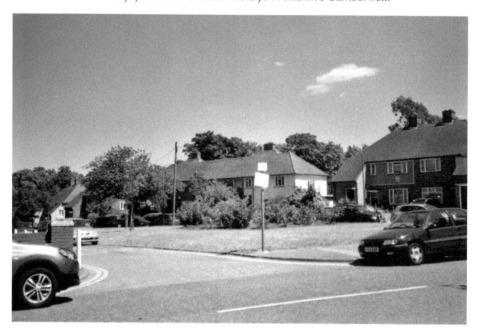

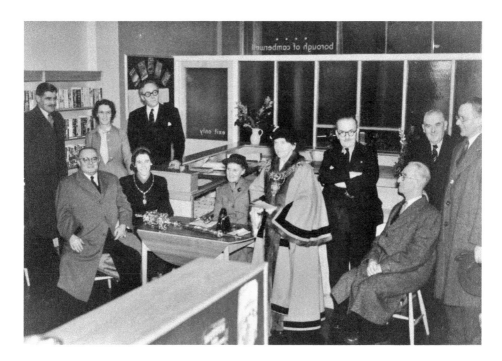

Library

Bessemer Grange Library in Crossthwaite Avenue was opened on 19 December 1953. The Mayor of Camberwell is Councillor Miss Rosina Whyatt. Sitting on her right is Alderman Mrs Jessie Burgess, Chairman of the Libraries' Committee. Seated on her left is Alderman J. W. F. Lucas after whom Lucas Gardens were named. The Borough Librarian, Mr W. J. A. Hahn, stands behind the Mayor with his arms folded. The library closed in 1990. A dry cleaner's now occupies the premises where the library used to be.

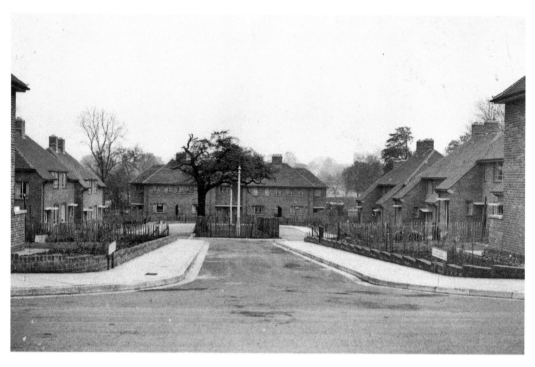

Gylcote Close

Gylcote Close, seen here in 1950, is on the Denmark Hill Estate. Gylcotes was a plot of land on Edward Alleyn's Dulwich Estate. Gylcote Close was built on the Bessemer Golf Course. This is shown on the 1895 Ordnance Survey Map.

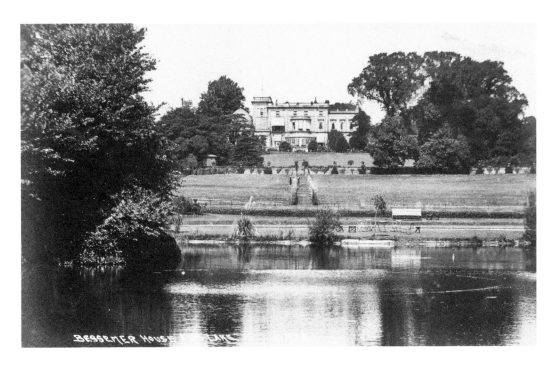

Sir Henry Bessemer

Sir Henry Bessemer (1813-98), who invented a steel manufacturing process, features in *Ye Parish of Camerwell* by W. H. Blanch. The book includes pictures of his 40 acre estate at Denmark Hill that he took possession of in 1863. Blanch refers to the 'beauties to be found in the grounds'. It included a 'charming lawn ... graced with deer'. In addition there were vineries, fruit trees, a peach house, a cucumber house, 'foreign plants of unsurpassable and rare foliage', ferns and palms. The views that Sir Henry had of hills in the distance can be seen from parts of the Denmark Hill Estate.

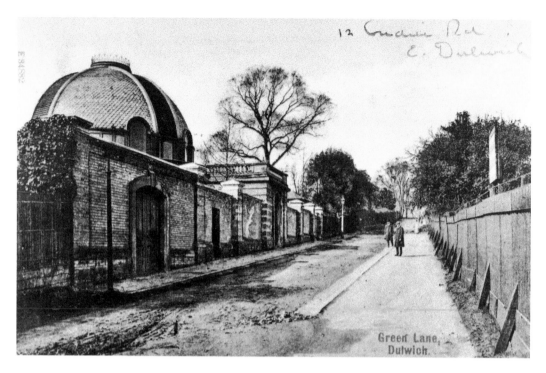

Green Lane,
Dulwich.

Observatory

There was an observatory on Sir Henry Bessemer's estate. This could be seen from Green Lane (now called Green Dale). Close to the observatory was a Model Farm which is included in *East Dulwich: An Illustrated Alphabetical Guide*; the farm terminated at the railway cutting. A large number of people now live where Bessemer's estate used to be but there is still a semi-rural atmosphere in Green Dale.

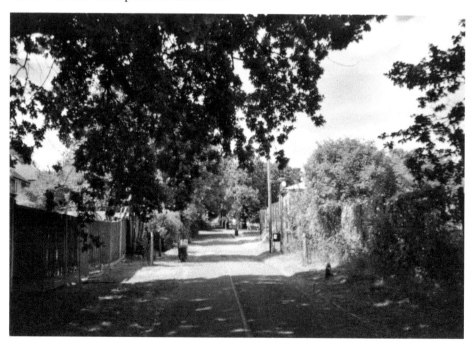